The Campus History Series

NORTH PARK UNIVERSITY

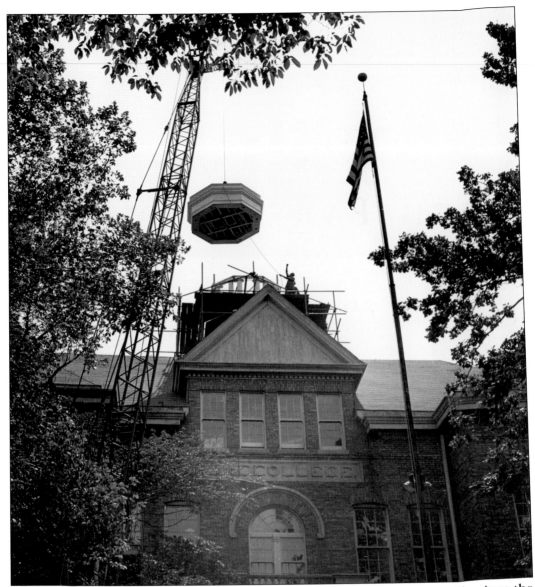

The North Park University campus and community has changed dramatically since the cornerstone of Old Main was laid on September 26, 1893. As buildings were added to the campus, the rural community surrounding it disappeared, and shops, bungalows, and apartment buildings replaced the forests, cabbage patches, and cornfields. Although Old Main appears the same, the cupola was damaged by strong winds in 1965 and subsequently replaced. (Courtesy Covenant Archives and Historical Library.)

On the cover: Students pose for a jovial photograph at the gates in front of Old Main in 1946. Old Main is North Park University's most recognizable landmark and was the only building on campus when the school moved to Chicago in 1894. The building was added to the National Register of Historic Places in 1982. (Courtesy Covenant Archives and Historical Library.)

The Campus History Series

NORTH PARK UNIVERSITY

JOHN E. PETERSON ON BEHALF OF NORTH PARK UNIVERSITY

ARCADIA
PUBLISHING

Published by Arcadia Publishing
Charleston SC, Chicago IL, Portsmouth NH, San Francisco CA

Printed in the United States of America

Library of Congress Catalog Card Number: 2008936160

For all general information contact Arcadia Publishing at:
Telephone 843-853-2070
Fax 843-853-0044
E-mail sales@arcadiapublishing.com
For customer service and orders:
Toll-Free 1-888-313-2665

Visit us on the Internet at www.arcadiapublishing.com

*Dedicated to the faculty, staff, and students
who make North Park University a special place
and to my wife Linda, whom I met
when we were students there*

CONTENTS

FOREWORD

A small band of Swedish immigrants gathered in Moses Hill, Nebraska, in 1891 and decided to start a college. This decision proved to have staying power. Over the past 12 decades, North Park University has become a comprehensive university with 3,300 students from across the country and around the world, enrolled in undergraduate, graduate, and theological studies. This is an impressive result from that initial gathering.

Several key factors give North Park its strength and unique character: a heritage within and continuing support from the Evangelical Covenant Church, a commitment to educating students in both the liberal arts and applied disciplines, a strong faculty comprised of exceptional teachers with deep commitments to mentoring students, a growing embrace of the urban setting, a spirit of innovation within a constancy of mission, and a loyal and generous cadre of alumni and financial supporters.

The university's challenging academic programs and supportive learning environment are molded by three core institutional values. Our learning community is (1) distinctively Christian—we nurture faith, balancing commitment and freedom, while affirming the historic Christian faith; (2) intentionally urban—we engage Chicago as our dynamic place of learning and service; and (3) purposefully multicultural—we embrace and value all people, celebrate the complex global cultural tapestry, and engage the reconciling mandate of the Christian gospel.

This is North Park University—past, present, and future. We trust that this historical photo essay appropriately reflects the university's dynamic past and points to our promising future.

—North Park University president David L. Parkyn

ACKNOWLEDGMENTS

In 1951, Philip E. Liljengren and E. Gustav Johnson compiled a book of historic photographs, *Sixty Years 1891–1951, A Scrapbook of Pictures Commemorating Three Score Years of North Park College*, that documented the history of North Park. I saw a copy of their book when I was a student at North Park College in the late 1960s, and that became the initial inspiration for this book. At that time, I was amazed by the number of changes that had occurred since they wrote the book 20 years earlier and thought it needed to be updated.

Now another 40 years have passed. There have been dramatic changes at North Park, and I was intrigued by the possibility of compiling a new pictorial history of the school. I want to thank North Park University's executive vice president Carl Balsam for his enthusiastic support when I suggested this project to him. Many thanks, as well, to the editorial committee that Carl Balsam convened for the project: Anne Jenner, Philip J. Anderson, Lilian Samaan, and Sally Anderson. Additional support came from many offices on campus. I am especially grateful for support from the Office of External Relations and the athletics department.

I want to thank Anne Jenner, the director of the archives and special collections at North Park University, for providing access to the archives and for her support and guidance and Joanna (Annie) Wilkinson, who provided much valued research as well as creative and technical assistance to Anne in locating and preparing the photographs. The archives has an extensive collection of photographs, historic documents, and artifacts for North Park University and the churches and institutions of the Evangelical Covenant Church. It was not difficult to find enough photographs from the collection for this book—the difficulty was choosing which photographs to use. A number of photographs had to be eliminated simply to keep this book a manageable size. Unless otherwise noted, all images appearing in this book are from collections of the Covenant Archives and Historical Library held at the F.M. Johnson Archives and Special Collections at North Park University.

Finally, to my wife Linda, thank you for your love and encouragement, not just on this project but in everything.

INTRODUCTION

Delegates from 63 Covenant churches in America met in Chicago to form a new denomination, the Swedish Evangelical Mission Covenant Church (now the Evangelical Covenant Church) in February 1885. During that meeting, they accepted an offer from Chicago Theological Seminary to establish a Swedish department where Covenant students would be trained for the ministry.

Despite this arrangement, the Covenant Church soon concluded that it needed its own school and at its 1891 annual meeting decided to establish one. Rev. Erik August Skogsbergh offered to give the denomination a small private school that he had started in 1884 for Swedish immigrants in Minneapolis. His offer was accepted, and the school opened under Covenant auspices in October with Prof. David Nyvall serving as its first president.

The school met in the basement of Skogsbergh's Swedish tabernacle church in downtown Minneapolis during its first three years. It started with two departments: a commercial department and a seminary. Although the school was called a college and seminary, the commercial department was essentially a high school and the seminary was essentially an undergraduate Bible school that provided basic training for students entering the ministry. The school added a preacademy the following year for students who lacked an elementary school education.

Although some leaders believed that the denomination simply needed a Bible school to train ministers, Nyvall had a broader vision for the new school. He wanted the school to consist of a college that offered general education courses in a wide range of disciplines taught in a Christian context and a seminary that provided a graduate-level education. Nyvall's ultimate dream was for the school to become a university.

The school soon became too large for the church basement and needed its own campus. The 1892 Covenant annual meeting decided to solicit offers from communities and accept the offer that was most advantageous. The two most likely sites were Chicago and Minneapolis because both cities had a large Swedish population and were centers for Swedish American activities.

Skogsbergh wanted the school to remain in Minneapolis. Local developers promised to give him 10 acres of land in suburban St. Louis Park, but the panic of 1893 altered their plans. Skogsbergh scrambled to find a different location for the school and was offered five acres of land in Camden Place. He promised to personally finance a building as a donation to the school.

The school also received two offers from the Chicago area from groups that wanted to attract the school because they believed it would enhance the value of their real estate developments. The Belt City Improvement Association offered 10 acres of land and $25,000 in cash for a building if the school moved to its development located near Aurora, 30 miles west of Chicago. The Swedish University Land Association offered eight and one-half acres of land in the North Park community northwest of Chicago and promised to give the school $15,000 to construct a building and $10,000 to establish an endowment fund.

The denomination ultimately accepted the offer from the Swedish University Land Association and moved the school to its present location in North Park, a rural community that had only nine homes at that time. The cornerstone of Old Main was laid on September 26, 1893, the completed building was dedicated on June 16, 1894, and classes were held in the new building in the fall. Old Main was the only building on campus and served as a dining hall, dormitory, and chapel, as well as a classroom building.

The campus was surrounded by onion farms, cabbage patches, and cornfields, and forests grew north and east of the campus. The North Branch of the Chicago River was a sluggish stream on the southern boundary of the campus crossed by wooden bridges at Kedzie, Spaulding, and Kimball Avenues. The river froze over during the winter and overflowed its banks in the spring.

The school's isolated location, lack of public transportation, and poor roads created accessibility problems for students and visitors and resulted in low enrollment during its first few years in Chicago. The Chicago and North Western Railroad station was located three miles east of campus, and the nearest streetcar was at Lincoln Avenue. People either walked to campus or were met by a school representative who drove a horse and buggy nicknamed the "North Park coach."

The school added academy (high school), music, and primary departments in the fall of 1894. English gradually replaced Swedish in the classrooms as the second-generation Swedish American students rejected many Swedish traditions, including the use of the Swedish language. The change of language enabled the school to broaden its appeal and attract non-Swedish and non-Covenant students. The exception was the seminary, which continued to teach its classes in Swedish, because it was the language spoken in the Covenant churches, and no one expected that to change in the foreseeable future.

During the first decade, nearly one-half of the academy students came from rural communities in several different states where the local schools did not offer high school classes. A junior college was added in the fall of 1902, but it was discontinued two years later due to low enrollment.

The school wanted to add a men's dormitory and a home for the president. This became possible when P. H. Anderson, a Covenant missionary in Alaska, staked a claim during the Alaskan gold rush and struck it rich. It became the third-largest claim during the gold rush and paid out more than $300,000. He donated $25,000 to the school in 1901 to construct the men's dormitory (the present Wilson Hall) and a home for the president, but his donation ultimately led to North Park president David Nyvall's resignation four years later. Most of the denominational leaders thought Anderson's claim belonged to the denomination because he was employed by the Covenant when he staked his claim. Nyvall was one of the few leaders who thought Anderson had a legal right to the claim, although he believed Anderson had a moral obligation to give more to Covenant causes. This created tension with the other leaders and made it impossible for Nyvall to remain at North Park College.

The Covenant Church took legal action against Anderson in 1903. It resulted in two decades of litigation before the case was ultimately decided in Anderson's favor by the United States Supreme Court in 1920. Anderson used approximately half the money he received from the mine to pay his legal fees.

David Nyvall was North Park College's first president. He served as president from 1891 to 1905 and from 1912 to 1923, a total of 25 years. Nyvall was born in Sweden in 1863 and emigrated in 1886. He also served as president of Walden College (a college started by Covenant churches in Kansas) from 1905 to 1908 and was the inaugural professor of Scandinavian languages and literature at the University of Washington from 1910 to 1912.

A. W. Fredrickson became the second president of North Park College after Nyvall resigned in 1905. He had serious health problems caused by diabetes and died in office in 1909. The popular teacher had joined the North Park Academy faculty in 1895.

One

THE EARLY YEARS

David Nyvall resigned as president in 1905, and A. W. Fredrickson served as the second president of the school until his untimely death in 1909. Rev. Carl Hanson was called to teach in the seminary and served as acting president for two years, from 1909 to 1911. C. J. Wilson served as acting president during the 1911–1912 academic year.

Nyvall accepted the call to return as president in 1912. English had replaced Swedish as the primary language of instruction in the seminary by 1913, although classes devoted to the study of the Swedish language were added to prepare ministers who would serve in churches where they would be expected to preach in Swedish. By 1920, a preparatory class in Swedish was required for all entering seminary students and continued to be a requisite until 1950.

The gymnasium-auditorium building (now Hamming Hall) was added to the campus in 1916. Critics of the project condemned athletics as worldly and incompatible with a Christian lifestyle. They referred to the building as a "gym-house" or "Nyvall's playhouse." Supporters of the project referred to the building as an auditorium instead of a gymnasium and emphasized its educational benefits, because it provided larger space for worship and additional facilities for the music department.

The departments at North Park College gradually changed. The junior college department was reestablished in 1919, and a Bible institute was added in 1921. The primary department closed in 1924. The commercial department closed one year later, and its classes were incorporated into the academy and the junior college. The following are enrollment numbers from the early 20th century:

Enrollment	1899–1900	1909–1910	1919–1920
Primary	11	18	14
Academy	12	27	82
Commercial	26	38	28
Junior College			12
Seminary	15	27	31
	64	110	167

Erik August Skogsbergh (1850–1939) was a pioneer Covenant pastor and evangelist who served churches in Chicago, Minneapolis, and Seattle. He organized a school for Swedish immigrants when he was in Minneapolis in 1884 and donated the school to the denomination in 1891.

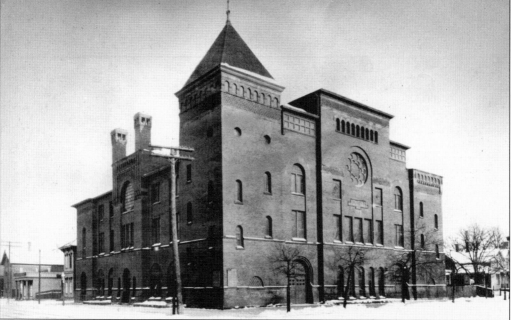

The school met in the basement of Skogsbergh's Swedish tabernacle in Minneapolis (now First Covenant Church) from 1891 until the move to Chicago in 1894. Former Covenant president C. V. Bowman recalled that on cold winter days "neither the teachers nor students could keep warm. . . . [They] sat in the classrooms during these days wearing overcoats and furs." The church was built in 1886 and is still used by the congregation.

The school had three departments when it issued its 1892–1893 catalog: the seminary, the commercial department, and the preacademy. The name of the school is listed at the top of the page. The school was officially named the Swedish Evangelical Mission Covenant College and Seminary at the 1892 Covenant annual meeting.

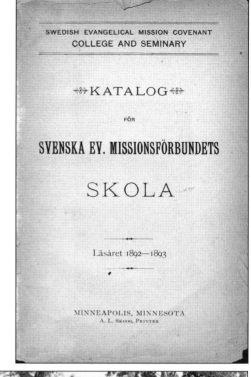

SWEDISH EVANGELICAL MISSION COVENANT
COLLEGE AND SEMINARY

◈KATALOG◈

FÖR

SVENSKA EV. MISSIONSFÖRBUNDETS

SKOLA

Läsåret 1892—1893

MINNEAPOLIS, MINNESOTA
A. L. SKOOG, PRINTER

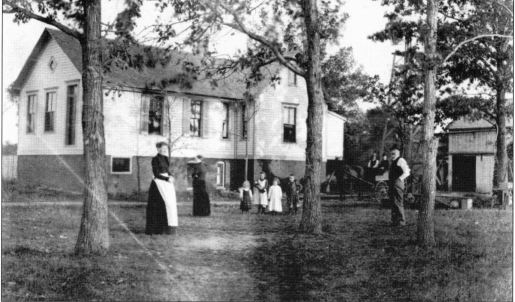

The Claus August Youngquist farm was located on Foster Avenue between Kedzie and Spaulding Avenues. The Swedish University Land Association purchased his eight-and-one-half-acre farm and donated the land to the denomination for the school. Old Main now stands where the farmhouse stood. North Park College students used Youngquist's pump to supply water until city water lines were extended to the campus in 1896, and the pump was removed.

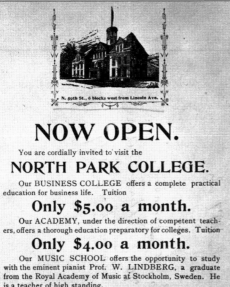

N. 50th St., 6 blocks west from Lincoln Ave.

NOW OPEN.

You are cordially invited to visit the

NORTH PARK COLLEGE.

Our BUSINESS COLLEGE offers a complete practical education for business life. Tuition

Only $5.00 a month.

Our ACADEMY, under the direction of competent teachers, offers a thorough education preparatory for colleges. Tuition

Only $4.00 a month.

Our MUSIC SCHOOL offers the opportunity to study with the eminent pianist Prof. W. LINDBERG, a graduate from the Royal Academy of Music at Stockholm, Sweden. He is a teacher of high standing.

Careful attention is given to every pupil. Tuition

Only $7.00 a month.

☞ For particulars write to:

North Park College, Station X, Chicago, Ill.

Respectfully yours

D. NYVALL, Principal.

Although the school's official name was the Swedish Evangelical Mission Covenant College and Seminary, this advertisement shows it was also called North Park College after the school moved to Chicago. The name was officially changed to North Park College and Theological Seminary in 1907. Foster Avenue was still North Fifty-ninth Street, and the school's address was Station X when this advertisement appeared in the mid-1890s.

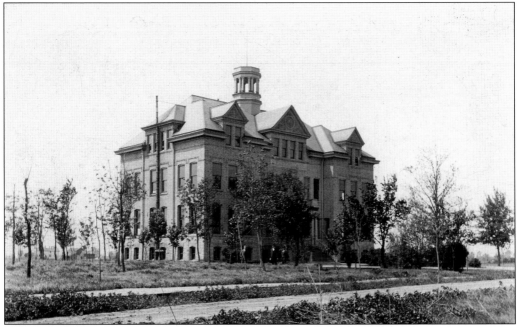

Old Main was the only building on campus. It was well built but lacked modern conveniences. The closest telephone was one-half mile east at the Covenant Home of Mercy. Old Main was lit by kerosene lamps, because gas and water lines had not been extended from the city. Foster Avenue was a muddy wagon road and was described as "well-nigh impassable" after a heavy rain.

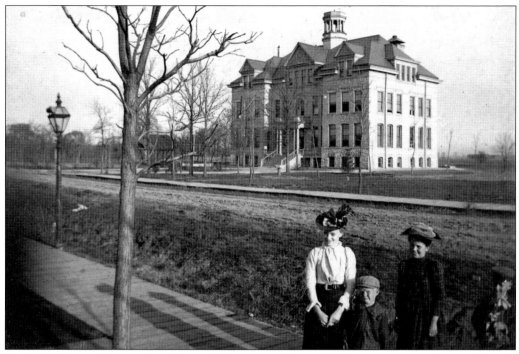

By 1895, Foster Avenue had been laid out, catalpa and elm trees were planted, board sidewalks were constructed, and gas streetlights were installed. The streetlights can be seen in this photograph showing a family posing in front of Old Main. Despite these improvements, the North Park neighborhood was still a rural community.

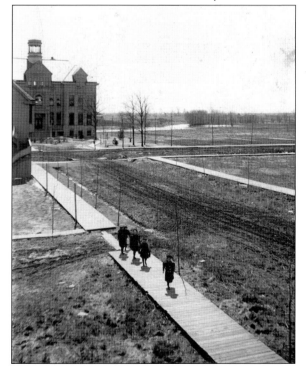

The lack of development around the school is evident in this photograph of Sawyer Avenue. It was the most important north–south street in the North Park community and was hard-surfaced long before Kedzie Avenue was opened north of Foster Avenue. Cronstedt's grocery store is on the left side of the photograph in front of Old Main. It opened in 1896 and was the area's first retail establishment. The North Branch of the Chicago River is visible behind Old Main.

Most of the lots north of the campus were not sold when this photograph showing the area between Sawyer and Kedzie Avenues was taken. The Swedish University Land Association hoped to sell 802 lots, but as a result of the economic depression beginning in 1893, only 100 lots were sold by the end of that year. This caused financial problems and forced the association to renege on its pledge to provide an endowment for the school.

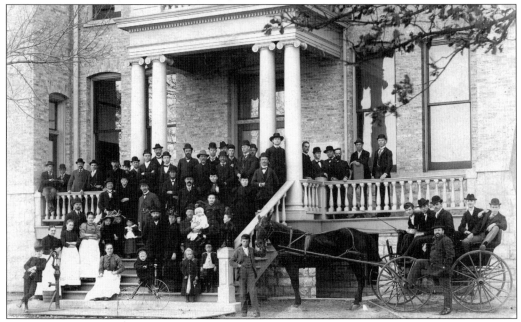

Students and faculty pose in front of Old Main in the fall of 1894. David Nyvall is in the center holding the baby. Louisa Nyvall is on his left and Axel and Erika Mellander are on his right. The horse and buggy transported people to the school and was called the North Park coach. The pump on the left was used until water lines were extended to the campus in 1896.

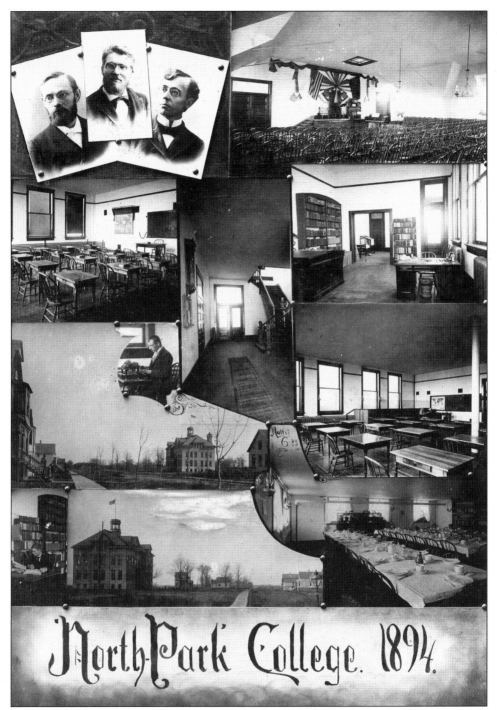

This cabinet photograph was distributed as a promotional piece in 1894 to show prospective students pictures of Old Main and North Park College's new Chicago campus. The men in the photographs in the upper left are, from left to right, Axel Mellander, David Nyvall, and J. A. Lindblade. The photograph in the middle left shows Foster Avenue looking east, and the one beneath it shows Foster Avenue looking west.

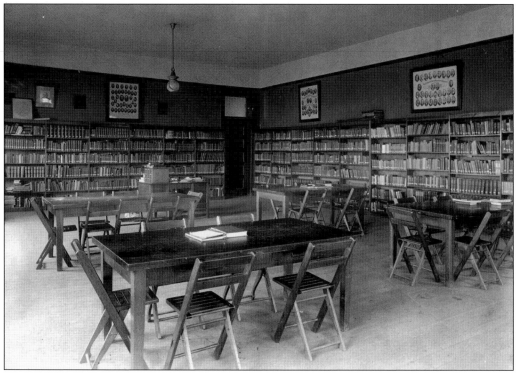

The library in Old Main was used by academy, college, and seminary students. It was originally located on the first floor of Old Main. It was moved to larger rooms on the second floor in 1915 and on the third floor in 1922. The seminary library moved to Nyvall Hall in 1947, and both the college and seminary libraries moved to the new Wallgren Library in 1958.

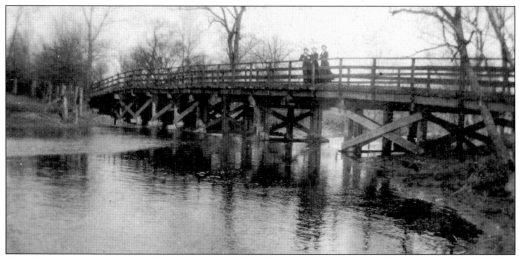

The Kedzie Bridge over the North Branch of the Chicago River located on the eastern boundary of the campus was originally a wooden bridge. The bridge was replaced with an iron bridge when the North Park community was annexed by the City of Chicago in 1899.

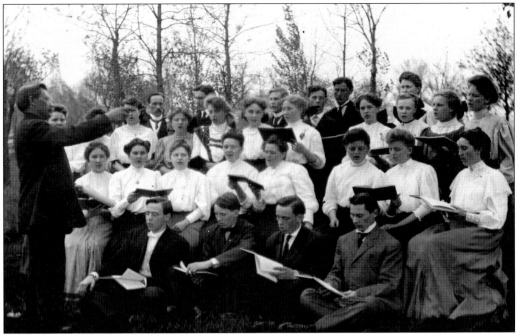

N. R. Goranson is shown directing the school's first choir. Goranson joined the faculty when the school moved to Chicago in 1894 and organized and directed the choir, band, orchestra, and various choral groups.

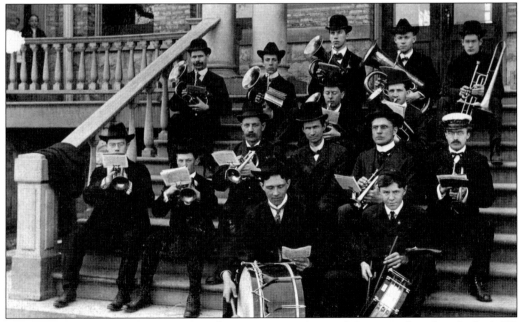

Goranson organized the brass band in 1901. Members of the 1901 band include A. W. Fredrickson in the second row, center; A. Samuel Wallgren, second from the left at the top; and David Gustafson, second from the right at top. Goranson and his son Arthur are third and second from the left in the front. Members of the band paid 2¢ an hour to use the instruments.

P. H. Anderson went to Alaska as a missionary for the Covenant Church after he graduated from the seminary in 1897. His gold mine was the third-largest claim during the gold rush, and he donated $25,000 to the school in 1901 to build a dormitory for men and a home for the president. He wanted the school to use the remaining money to build a gymnasium-auditorium "if sufficient funds were available."

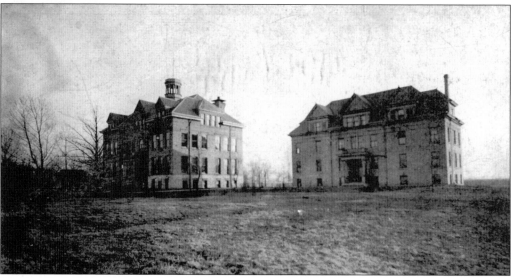

The men's dormitory (right), constructed in 1901, is the second-oldest building on campus. It housed 50 men on the upper three floors. The dining hall, located in the basement, replaced the former dining hall in Old Main. It cost $16,747 to build both the men's dormitory and the president's home. The men's dormitory was remodeled into a classroom building in 1940 and renamed Wilson Hall.

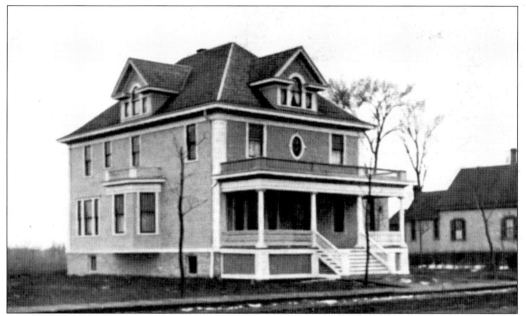

The president's home was built at the corner of Foster and Spaulding Avenues in 1902. It was used as a women's dormitory (1920–1925), a music building (1925–1947), an art building (1948–1958), and a student services building (1958–1966) before it was torn down in 1966. Anderson Chapel was built on this site in 1993.

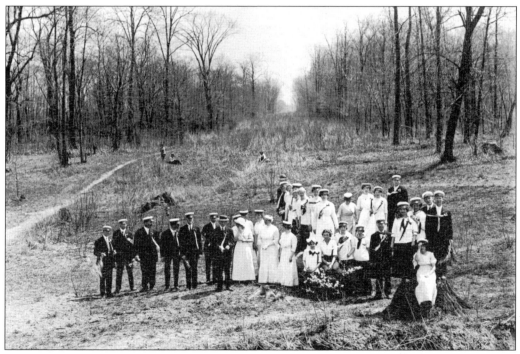

Students enjoyed outings at nearby Budlong Woods, located northeast of the campus. This photograph looks north from Foster Avenue. Student outings included picnics, parties, receptions, birthday parties, and sleigh rides.

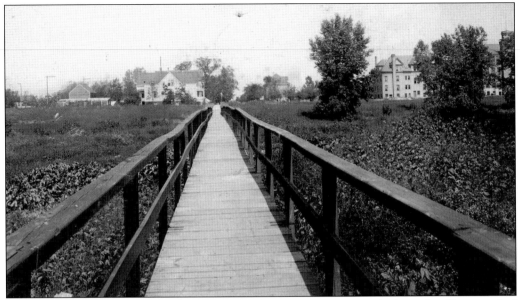

A footbridge crossed the North Branch at Spaulding Avenue, and a boardwalk extended across the wetlands toward Foster Avenue. There stood the home of John Leaf, where some students found housing. It was built in 1893 and purchased by the college in 1953. The president's home is in the center of the photograph, and the men's dormitory (now Wilson Hall) and Old Main are on the right.

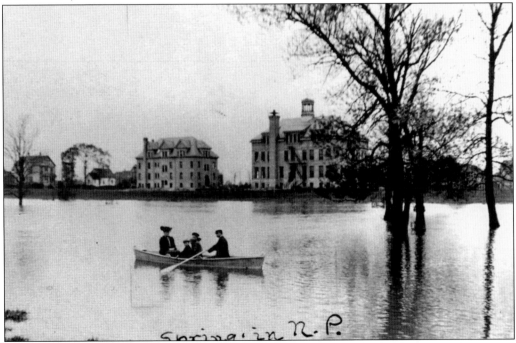

When the North Branch overflowed its banks in the spring, the back campus became a lake. This 1904 photograph shows a family enjoying the floodwaters in its rowboat. The men's dormitory and Old Main are in the center of the photograph. John Leaf's home is on the far left side.

This 1903 photograph of the customary Swedish May Day celebration shows women dressed in colorful Swedish costumes and men wearing white caps, the classic academic insignia of Swedish students. Festivities began at 3:00 p.m. with a picnic followed by athletic contests. The North Branch was nicknamed the Jordan River during tug-of-wars between classes pulling from opposite sides of the river. Activities concluded in the evening with bonfires, debates, speeches, and musical numbers.

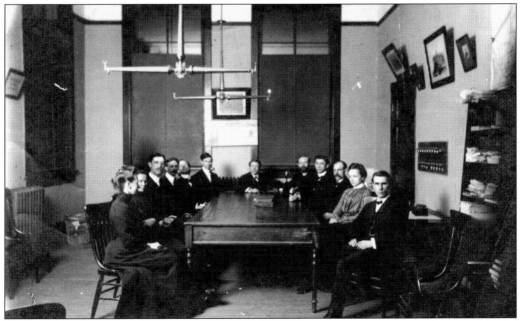

North Park College's faculty in 1902 are, from left to right, Marie Hellstrom, Lena Sahlstrom, Gustaf Holmquist, C. J. Wilson, J. A. Lindblade, A. W. Fredrickson, David Nyvall, Axel Mellander, Alfred N. Ahnfeldt, Emil Larson, Lydia Erickson, and C. F. Fredrickson. Notice the acetylene gas lamps in the ceiling fixture above the table that were installed in 1899. Electric light fixtures were not installed in Old Main until 1913.

Axel Mellander was the first dean of the seminary, serving from 1892 to 1922. He was pastor of the Covenant church in Iron Mountain, Michigan, before coming to North Park Theological Seminary. Mellander was regarded as a good teacher who was appreciated by students for his strict discipline and thorough instruction.

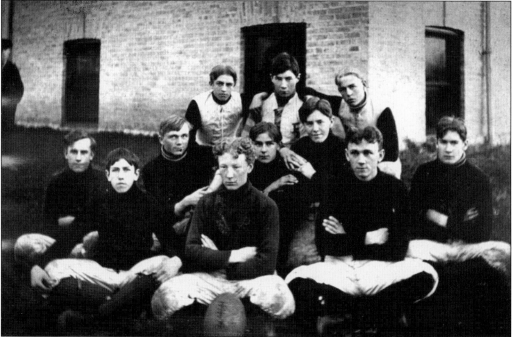

North Park College played its first football game on October 21, 1899, and lost to a team from North Division High School. The 1903 football team was the school's last one until 1934 because the 1904 Covenant annual meeting directed the school to eliminate all athletic events and other activities that were "offensive to Christians."

The wooden bridge on Spaulding Avenue, southwest of campus, was a popular place where many campus romances began. A student in 1894 wrote that the old rural bridge "was a favorite place for the boys and girls during the moonlight evenings. There they would loiter about in the twilight, conversing, singing, and laughing. Don't get excited, classmates! I'll say no more on that delicate subject."

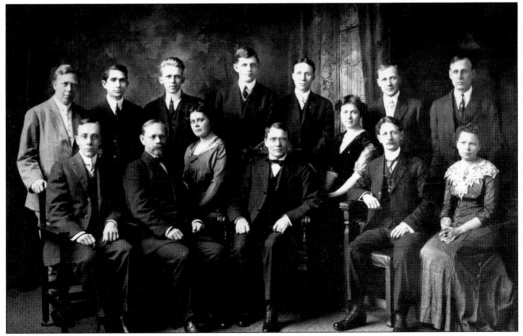

The faculty during the 1912–1913 academic year are, from left to right, (first row) A. Samuel Wallgren, Axel Mellander, Blanche Waldenstrom, David Nyvall, Minnie Cedergreen-Jernberg, C. J. Wilson, and Lena Sahlstrom; (second row) Frank Earnest, F. Justus Hollinbeck, David Nyvall Jr., Carl Lindegren, G. W. Blomquist, Charles Hjerpe, and A. E. Anderson.

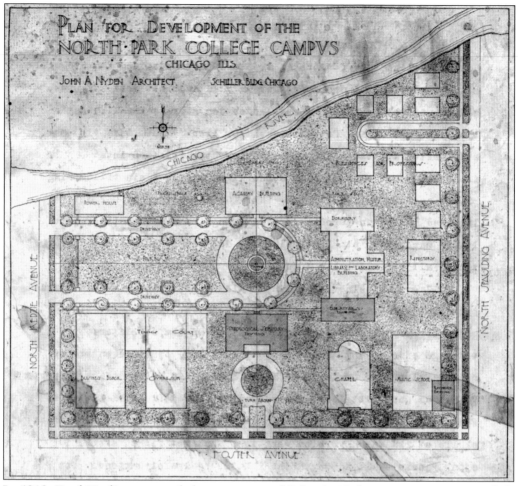

In 1913, Fred Norlin surveyed the campus and John A. Nyden, a prominent Swedish American architect from Chicago, drew plans for future campus development that showed sites for proposed buildings. Nyden's plan showed a circular drive from Kedzie Avenue extending to a new administration building. The proposed buildings were, clockwise from lower left, a business building, a power plant, an academy building, faculty homes, a refectory (dining hall), a music school (replacing the president's residence), and a chapel. Located behind the men's dormitory is a women's dormitory with an administration building connecting the two dormitories. Tennis courts are shown behind the gymnasium.

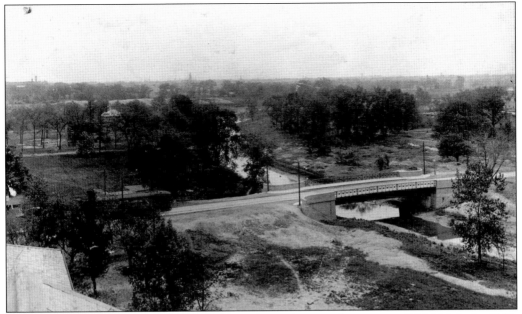

These two bird's-eye photographs, taken from the cupola on top of Old Main in 1915, show that most of the land in the community was still undeveloped. The photograph below looking northwest shows the president's home in the foreground. All the buildings fronting Foster Avenue have been replaced except the building across from the president's home. That building is currently used by the Tre Kronor restaurant. The photograph above looking southeast shows a streetcar north of the Kedzie Bridge after it completed its northbound schedule. The streetcar line was extended to Foster Avenue in 1915.

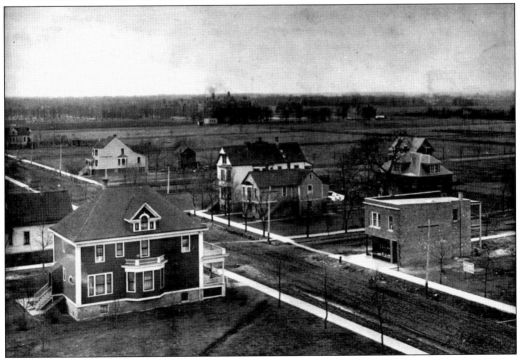

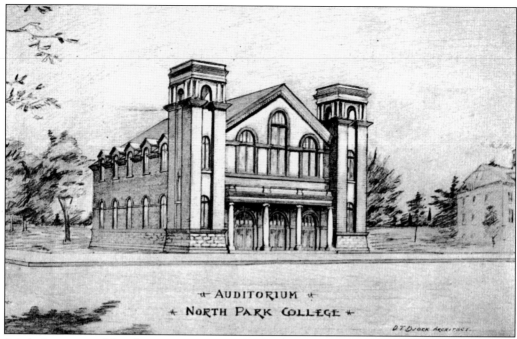

AUDITORIUM
NORTH PARK COLLEGE

An early proposal for the new gymnasium-auditorium shows a distinctive building with twin towers. The proposed building was too expensive, and the architects redesigned the building to lower the cost.

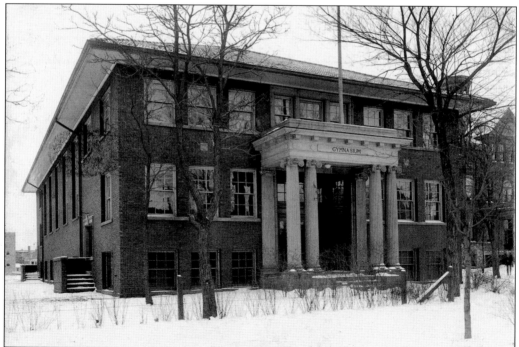

The gymnasium-auditorium (now Hamming Hall) was built in 1916 and designed by John A. Nyden. The $30,224 building was dedicated on April 30. The building also served as a music conservatory with six music studios on the main floor and in the balcony.

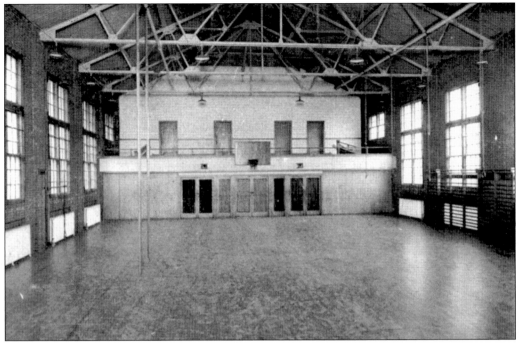

The basketball court was on the main floor of the gymnasium-auditorium. It was not a full-size court, and there was no room for bleachers along the side. Spectators had to sit behind the baskets in the balcony or on the stage.

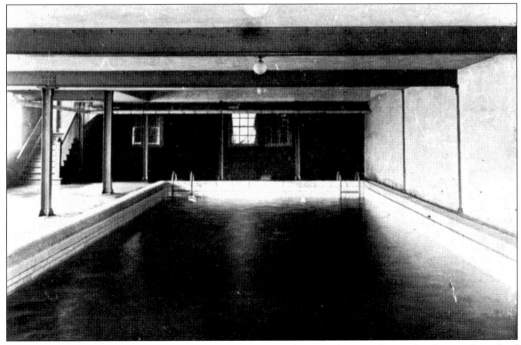

The locker rooms and indoor swimming pool were located on the lower level of the gymnasium-auditorium. The small 60-by-20-foot pool was used by the school until 1999.

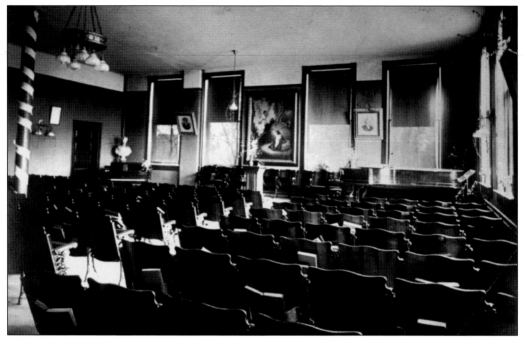

Chapel services were held in the auditorium in Old Main. As enrollment increased, the services outgrew Old Main and were moved to the gymnasium-auditorium. Attendance was required, and folding chairs were set up to accommodate the worshippers. The services were moved to the new gymnasium in 1965. When the board of directors eliminated required attendance at chapel services in 1970, the services were moved back to the chapel (old gymnasium).

Students were trained in gymnastics by John V. Kling, who served as an instructor without pay from 1914 until 1917, when there was an increased emphasis on physical education. A field was leveled near the school in 1913, and additional equipment was added in the gymnasium that was located in the basement of Old Main. Students' demonstration in 1915 included "field events, acrobatic stunts, and feats of strength."

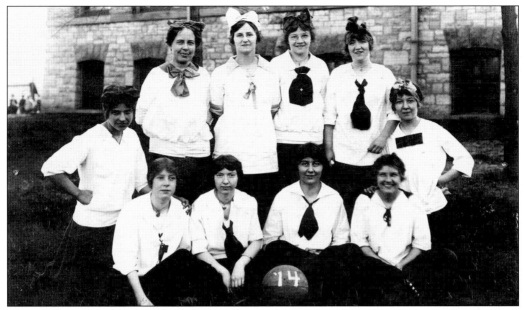

The academy's girls' basketball team still wore bloomers when this photograph was taken in 1914. The junior college sponsored women's varsity athletic teams in the 1920s, but the women's teams were disbanded and replaced by intramural activities in 1929. North Park College eliminated the women's teams because it was considered "unladylike" for women to compete against teams from other schools.

Coach Harry Edgren started a baseball team in the spring of 1920, the junior college's first academic year. This became the first athletic team sponsored by the junior college. This photograph shows one of early baseball teams from the 1920s.

Algoth Ohlson became the third president of North Park College in 1924. He was an ordained minister in the Covenant Church and served churches in Danbury and Bridgeport, Connecticut; Lowell, Massachusetts; and Chicago before coming to North Park. Under his leadership, the college became a respected junior college, and the seminary increased its academic standards.

Nils Lund was dean of the seminary from 1925 to 1948. He graduated from North Park Theological Seminary in 1910 and was pastor at Covenant churches in Lindsborg, Kansas, and Lynn, Massachusetts. He was pastor at the Swedish Congregational Church in Boston when he accepted the call to teach at North Park Theological Seminary in 1922.

Two

DEPRESSION AND WAR YEARS

Algoth Ohlson replaced David Nyvall as president in 1924 and served for 25 years, encompassing the prosperous 1920s, the Depression-ridden 1930s, and the war and postwar periods of the 1940s.

The junior college was accredited by the North Central Association in 1926. The successful Greater North Park Campaign provided funds for the school to build a new dormitory for women, a new residence for the president, and a new heating plant. Caroline Hall, the women's dormitory, was funded by donations from the Covenant Women's Auxiliary. The auxiliary also raised funds to build the gates in front of Old Main.

Enrollment in the junior college grew rapidly during the Depression. North Park College's low tuition rates attracted Chicago-area students who could not afford to attend out-of-town colleges, and the school gained additional students when some Chicago junior colleges closed as the Depression worsened. Enrollment increased from 169 in 1930 to 653 in 1940. The influx of these non-Covenant commuter students from a wide variety of ethnic and religious backgrounds changed the distinctive Covenant character of the school.

Academy enrollment declined during the Depression as parents chose to send their students to public schools, then increased when the economic conditions improved and was subsequently capped because of a lack of facilities. The school began to need additional facilities for the increased number of junior college and academy students and purchased the Lundholm apartment building (now Ohlson House) in 1940 to use as a dormitory for men. That same year, the old men's dormitory was renovated as a classroom and science laboratory building named Wilson Hall in honor of C. J. Wilson.

After World War II, the school unveiled an ambitious 10-year plan to construct eight new buildings, but only two of the buildings, Hanson Hall and Nyvall Hall, were actually built. Hanson Hall provided facilities for the music department, and Nyvall Hall was built as a seminary classroom building with Isaacson Memorial Chapel in the south wing and the seminary library in the north wing. Some enrollment numbers during this time period are as follows:

Enrollment	1929–1930	1939–1940	1949–1950
Academy	161	445	472
Junior College	169	653	652
Bible Institute	7	15	17
Music	5	36	43
Seminary	32	68	81
	374	1,217	1,265

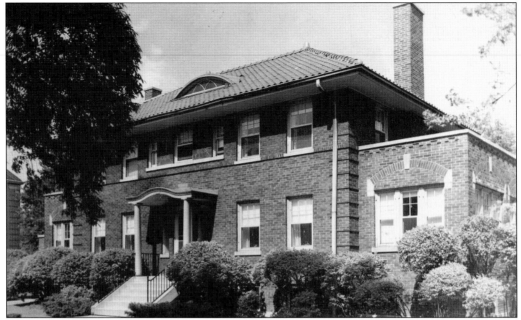

College president Algoth Ohlson and his family were the first residents to live in the new president's home. The house was built in 1924 at a cost of $16,830. It was renovated, enlarged, and converted into the central administration building in 1957. The building currently houses the Office of Student Administrative Services, a multifunctional department that houses the academic records, financial aid, and student accounts.

Two tennis courts were constructed north of the president's home in 1925. The courts were dedicated on April 21 by Ohlson, who "succeeded after a few attempts in hitting one of the balls across the net." The men's dormitory (now Wilson Hall) is in the background. The tennis courts were removed when Hanson Hall was built on this site in 1946.

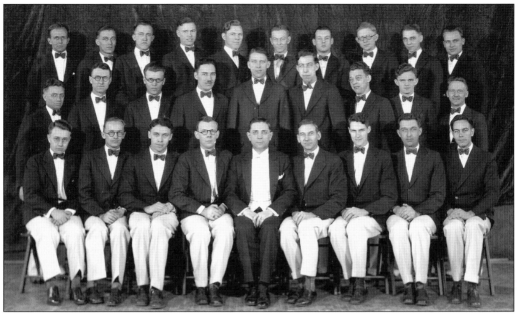

The men's glee club was directed by Frank Earnest, seated in the center of the first row. The men's and women's glee clubs were the premier choirs on campus during this period. Each year, the two glee clubs went on separate tours to Covenant churches in different regions of the country.

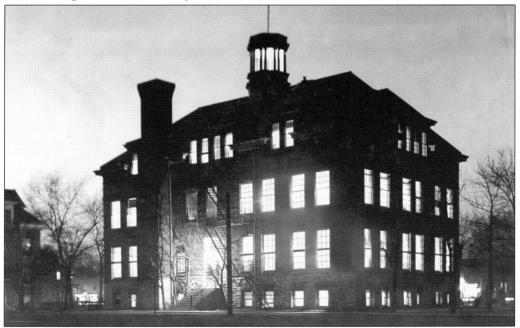

The cupola on top of Old Main was illuminated by electric lights in 1926. The *Chicago Journal* reported that "airmen using northwest aerial routes long ago spotted the cupola on the administration building and jotted it down on their air maps." The Birk Memorial chimes were given to the school in 1953 in memory of Bruce Birk, a navy pilot killed in World War II.

Caroline Hall, a dormitory housing 50 women, was built in 1925 at a cost of $56,000. It was named in honor of Caroline Sahlstrom, the first woman on the faculty and the first dean of women. Covenant Women's Auxiliary raised the money to build the dormitory through rummage sales, auctions, concerts, lectures, and a penny savings plan.

The dormitory rooms in Caroline Hall originally had movable armoires, but built-in closets were added when the building was remodeled in 1954. The campus dining hall moved from the basement of the men's dormitory (now Wilson Hall) to the lower level of Caroline Hall. The new dining hall had a seating capacity of 130 students.

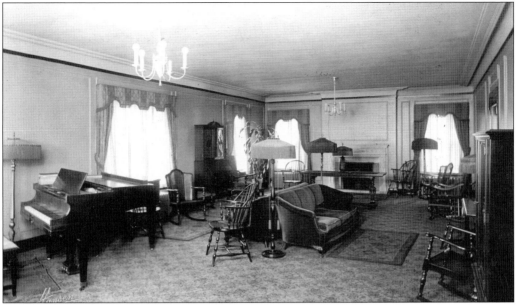

The lounge in Caroline Hall was a popular place where women could relax, play the piano, and spend time with their boyfriends. When Caroline Hall was converted into an administration building in 1966 following the construction of Anderson Hall, the lounge was used by the Office of Records. Caroline Hall currently houses the cultural centers, computer services, student computer laboratories, and several academic departments.

North Park College had the opportunity to purchase the 22-acre campus of recently closed Des Moines University for $203,000 in 1930. The larger facilities would enable the junior college to expand into a four-year college. Due to the financial uncertainties caused by the stock market crash the previous October, the board of directors decided the school should neither move to Iowa nor spend the $600,000 needed to start a four-year program. (Author's collection.)

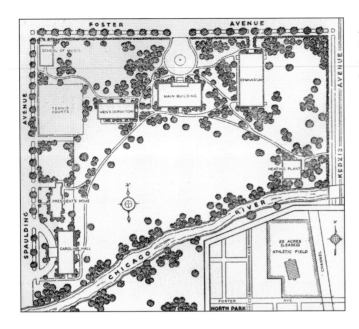

A 1937 campus map shows a proposed athletic field located north of Foster Avenue two blocks east of campus (insert, lower right). North Park College had the opportunity to buy 19 acres for campus expansion from the sanitary district for $20,000, and college president Algoth Ohlson asked the alumni association to raise the money. It raised only $3,500 and the opportunity to purchase the land was lost. The Chicago Transit Authority acquired most of this land in 1948.

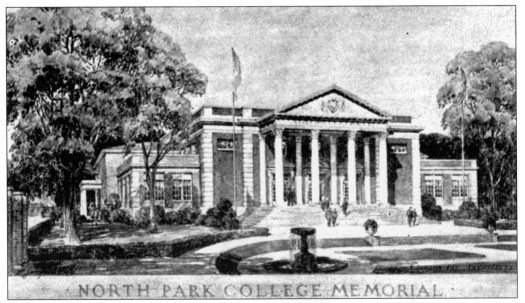

A proposed $100,000 addition on the west side of the gymnasium in 1937 would have added eight classrooms, a full-size gymnasium, and larger locker rooms and increased the capacity of the auditorium from 800 to 1,500 for chapel services. A sunken garden with Grecian fountains would have been installed in front of the new addition, replacing the circular drive in front of Old Main. The gymnasium addition was never built.

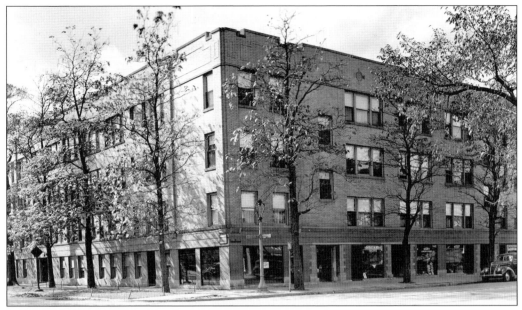

The Lundholm apartment building on the corner of Foster and Spaulding Avenues cost $140,000 to build in 1926. The owners could not make the mortgage payments during the Depression, and North Park College purchased the building for just $57,500 in 1940. It was used as a men's dormitory and housed 108 men in 24 apartments. The building was converted into a women's dormitory and renamed Ohlson House in 1961.

Each apartment in the Lundholm building had two rooms used for lounge and study and two rooms used for sleeping that contained three single beds and one bunk bed. Each apartment had its own bathroom, but the kitchens were removed. The *Chicago Tribune* noted, "North Park College is one of the few United States colleges to provide apartment living arrangements for its men students."

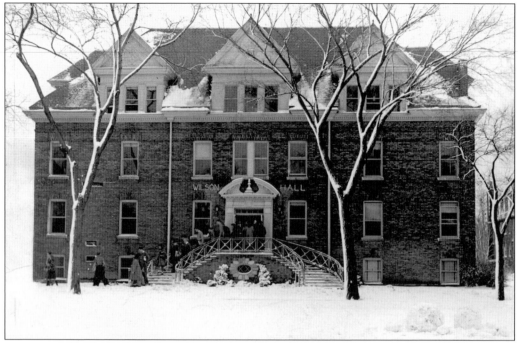

The men's dormitory (above) was converted into a science classroom and laboratory building and renamed Wilson Hall in honor of C. J. Wilson in 1940 after the school acquired the Lundholm building. The interior was torn out, the building was strengthened with steel girders, and a new main entrance with a curving stairway was constructed in front of the building. Wilson Hall had three laboratories, seven classrooms, and five faculty offices. Dr. Eldon Strandine is shown giving a lecture to a science class in Wilson Hall in the 1940s in the photograph below.

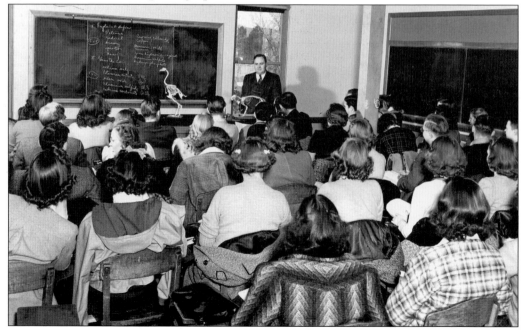

This photograph of the back campus, looking west from Kedzie Avenue in 1939, shows Caroline Hall (left) and the president's residence (center) in the background. Old Main is behind the trees on the right. This view dramatically changed when most of the land was used to build the new gymnasium in 1959 and Carlson Tower and the lecture hall in 1967. The back campus is no longer visible from Kedzie Avenue.

Some men wore skirts to class in 1943 to "shame" the women who wore slacks. The protest failed because the women were amused rather than upset. Dean of students Peter Person ordered the men to wear pants to class and promised disciplinary action would be taken against them. The Associated Press reported the girls continued to wear slacks and let their shirttails "fly defiantly in the breeze."

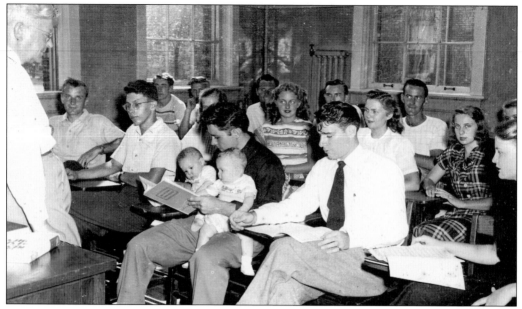

College enrollment increased after World War II when many veterans returned from the war and used money from the GI Bill to fund their education. Many of the veterans were older students, and some were married and had children. This 1945 photograph shows E. Gustav Johnson teaching a class in Old Main while a father holds two children on his lap.

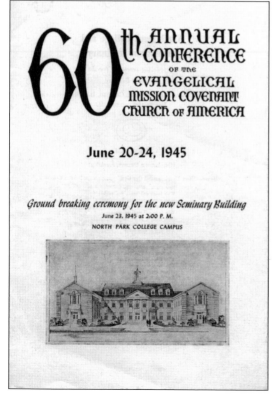

The groundbreaking ceremony for the new seminary building was held during the 60th annual meeting of the Evangelical Covenant Church. When the seminary moved into its new building, additional space was created in Old Main for the academy and the college.

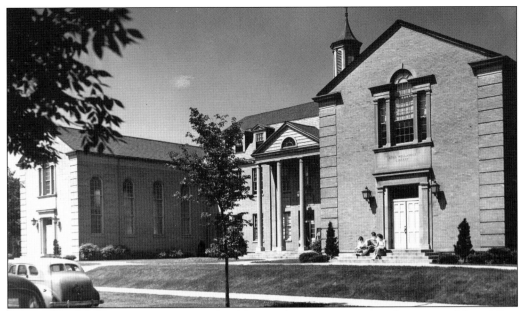

Nyvall Hall, the seminary classroom building with two wings extending toward Spaulding Avenue, opened in 1947 and was named in honor of David Nyvall, the first president of the school. It was built across from Caroline Hall on five lots donated to the school by Adolph Julin, who was president of the Swedish University Land Association when it donated the original eight and one-half acres of land to the school in 1893.

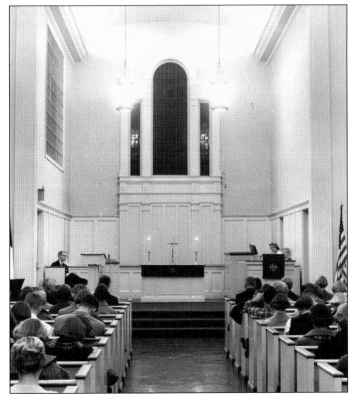

Isaacson Memorial Chapel occupies the south wing of Nyvall Hall. It has a seating capacity of 250 people and was named in honor of John Isaacson, a Covenant industrialist from Seattle. A $10,000 donation was used to purchase and install a pipe organ in the chapel in 1950.

The seminary library was located on the second floor of the north wing of Nyvall Hall. It was named Mellander Library in honor of Axel Mellander, the dean of the seminary from 1892 until 1922. The library was previously part of the combined college and academy library in Old Main. The Covenant archives moved into this room when Mellander Library moved to the third floor of the new Wallgren Library building in 1958.

The bookstore and infirmary, previously located in Old Main, and the academy cafeteria, previously located in the men's dormitory (Wilson Hall), reopened in the lower level of the Lundholm building in 1940. Retail stores had occupied that space before the school acquired the building.

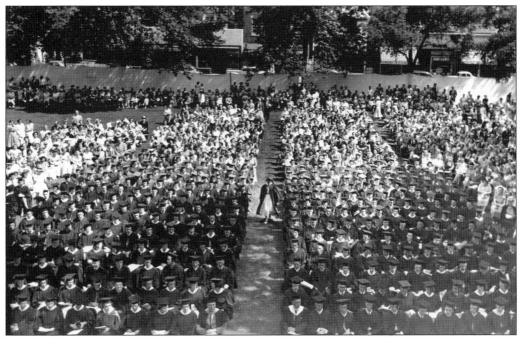

Commencement was held on the lawn in front of Wilson Hall and was moved to the assembly hall at nearby Hibbard Elementary School when the weather was bad. The commencement exercises were permanently moved indoors when the new gymnasium was built in 1959.

Hanson Hall, the music building named in honor of Mr. and Mrs. Emil Hanson, was built on the site of the tennis courts. The building opened in 1947. The lower level of Hanson Hall had a recording studio, a classroom, and 11 practice rooms. The second floor had two classrooms, an office, and eight studios. The third floor had two studios and a recital hall seating 200.

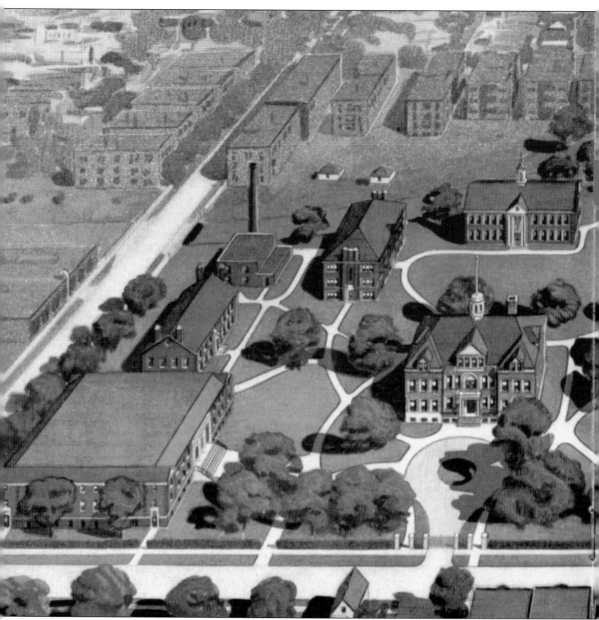

The school unveiled an ambitious $1.5 million 10-year plan following World War II to construct eight new Georgian Colonial–style buildings on the campus. The buildings are, clockwise from the lower left, a $275,000 gymnasium on the corner of Foster and Kedzie Avenues with a swimming pool on the lower level; a $80,000 arts and domestic science building south of the gymnasium on Kedzie Avenue for art and home economic classes; a $250,000 science building along the river with laboratories, lecture rooms, and

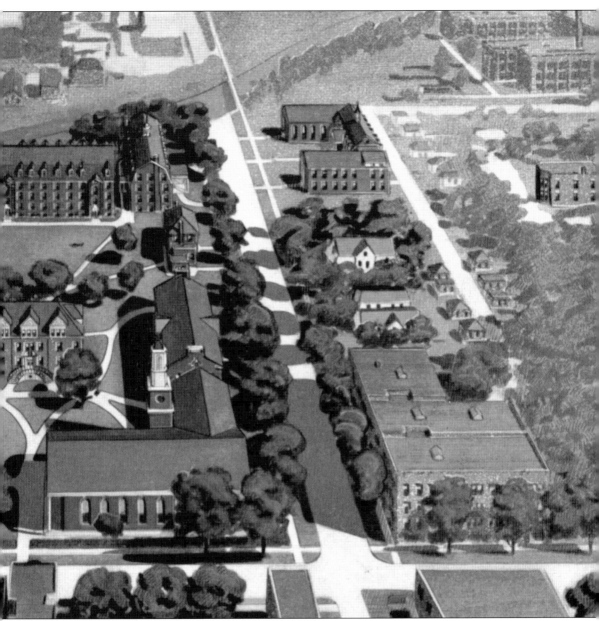

classrooms; a $200,000 library along the river behind Old Main; a $250,000 women's dormitory (housing 100 women) and dining hall behind Caroline Hall; Nyvall Hall (across the street from Caroline Hall); Hanson Hall; and a $275,000 chapel and student union at the corner of Foster and Spaulding Avenues. Nyvall Hall and Hanson Hall were the only two buildings built.

The school purchased the home of E. G. Hjerpe, former president of the denomination, in 1948. Hjerpe House was located on the south side of Foster Avenue a half block west of Kimball Avenue and served as a dormitory for 14 men (1948–1957) and women (1957–1965) before it was sold and ultimately torn down.

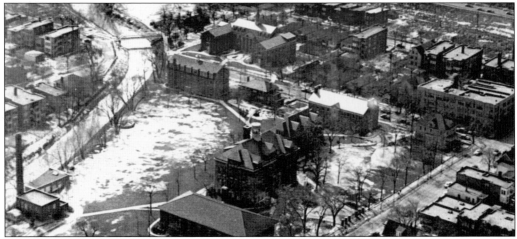

An aerial photograph of campus was taken from the corner of Foster and Kedzie Avenues following the construction of Hanson Hall and Nyvall Hall. The footbridge across the North Branch (top left) leads to land acquired by the school in 1954, where Burgh Hall, Anderson Hall, and the Magnuson Campus Center were eventually built. Sohlberg Hall was built in the open space shown at the top right.

48

Ted Hedstrand (center) was head coach of the academy's football and basketball teams, both of which were undefeated during the 1949–1950 academic year and won the private school championships. The football team had an 8-0 record, and the basketball team finished the season with a 25-0 record. Hedstrand was honored for this achievement when he was inducted into the Illinois Basketball Coaches Association Hall of Fame in 1980.

The 1949 academy football team finished with a perfect 8-0 record. This was the academy's first football championship in the private school league. The 1950 football team was also undefeated. The 1951 team finished the season with a 6-2 record and won the third consecutive private league title.

Clarence Nelson became president of North Park College in 1950 and served until he became president of the Evangelical Covenant Church in 1959. Nelson came to North Park from Minnehaha Academy in Minneapolis, a Covenant high school operated by the Northwest Conference. Nelson was president of Minnehaha Academy from 1943 until 1950.

Eric Hawkinson was the dean of the seminary when North Park Theological Seminary upgraded its requirements. When the seminary was granted associate membership in the American Association of Theological Schools, the school could confer bachelor of divinity degrees (instead of diplomas) to seminarians who completed the degree requirements. Seventeen men received the first bachelor of divinity degrees granted by the seminary in 1957. Hawkinson served as dean from 1949 until 1960.

50

Three

DREAMS FULFILLED

Clarence Nelson had two goals when he became the fourth president of North Park College and Theological Seminary in 1950: to expand the seminary into an accredited graduate institution and to expand the junior college into a four-year liberal arts college.

The seminary upgraded its requirements and became an associate member of the American Association of Theological Schools in 1954. It granted its first bachelor of divinity (now master of divinity) degrees in 1957. The college expanded its curriculum, and the college's first senior class received bachelor's degrees in 1960. The Bible institute (which was renamed the department of religious education in 1951) and the music department became part of the college when the college became a four-year institution.

New buildings and additional land were required to expand the schools, but the community had become fully developed, and land was expensive. North Park College briefly explored the possibility of relocating the campus to a 50-acre site located on Touhy Avenue in suburban Niles. The board of directors estimated it would cost $7 million to construct buildings at a new campus compared to the $1.5 million needed to build a new library and gymnasium on the present campus and decided the school should remain in Chicago.

North Park College began acquiring land around the campus. Sohlberg Hall, a dormitory for women, was built one block west of the campus in 1951, and Burgh Hall, a dormitory for men, was built on a newly acquired triangle of land south of the river in 1956. Homes on the west side of Spaulding between Nyvall Hall and the Lundholm building were purchased and demolished so the land could be used to construct the Wallgren Library–classroom building in 1958. The president's home was remodeled into an administration building in 1957, an athletic field was built two blocks east of the campus in 1958, and the new gymnasium-auditorium opened in 1959.

Over the course of the decade, overall enrollment at North Park increased.

Enrollment	1949–1950	1959–1960
Academy	472	399
Junior College	652	859
Bible Institute	17	*
Music	43	*
Seminary	81	84
	1,265	1,342

*Now included in the college enrollment

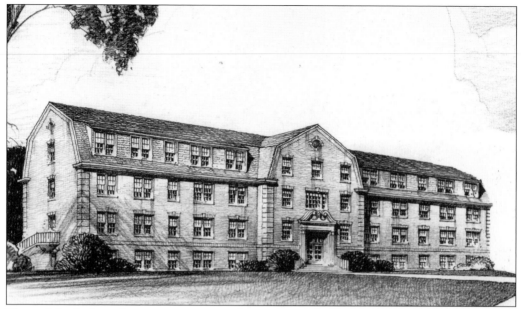

The original plans for a new women's dormitory (above) showed a building built in a Georgian Colonial design with a gambrel (barnlike) roof similar in appearance to Caroline Hall and Nyvall Hall. The plans were later changed, and the building was constructed in a modern style (below) with a flat roof. The dormitory was named Sohlberg Hall in honor of dean of women Helen Sohlberg.

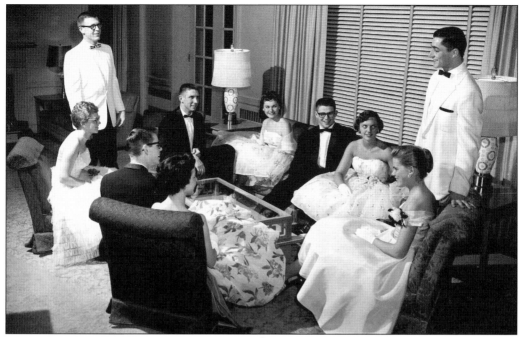

The lounge on the first floor of Sohlberg Hall was a popular place for residents to relax and entertain their boyfriends. The women could sunbathe on a large sun porch outside the lounge.

Sohlberg Hall was completed in 1951 and housed 105 women on the upper three floors. The dormitory was converted into a men's dormitory in 1966 after Anderson Hall was built, but it was not redecorated. The men complained about the "feminine appearance of the rooms and washrooms." They did not like the flowery wallpaper, light pink and green shower curtains, and the women's washroom facilities.

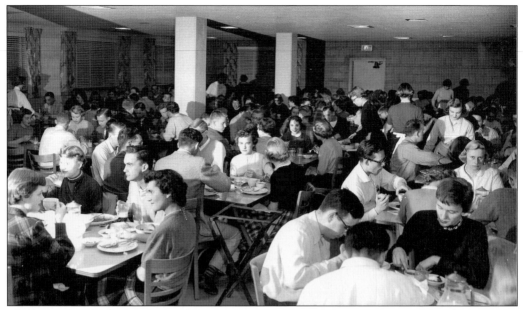

The lower level of Sohlberg Hall had a dining hall with a seating capacity of 450 people. The school's original dining hall was located in Old Main. It was then located in the basement of the men's dormitory from 1902 until 1925 and the lower level of Caroline Hall from 1925 until it moved to Sohlberg Hall. The lower level of Sohlberg now has classrooms, study areas, and university ministries offices.

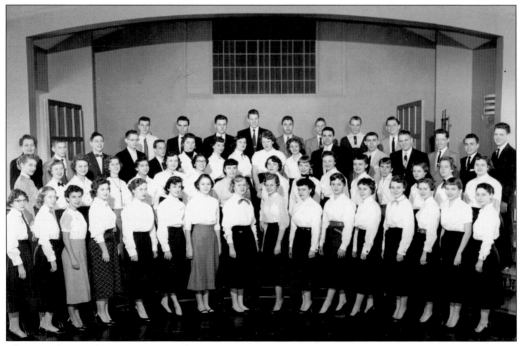

The academy choir poses on the stage in Hanson Hall's recital hall. Hanson Hall was used by both the college and the academy. The choir was renamed the Varsity Singers when Gregory Athnos became director in 1966.

When Herbert Johnson wrote the song "The Elm Tree's Shadow Lingers upon the Quiet Walls" to describe the school in 1927, there were large elm trees in front of Old Main and Wilson Hall. In the late 1960s, Dutch elm disease killed many of the trees shown in this photograph, but new trees were planted to replace them.

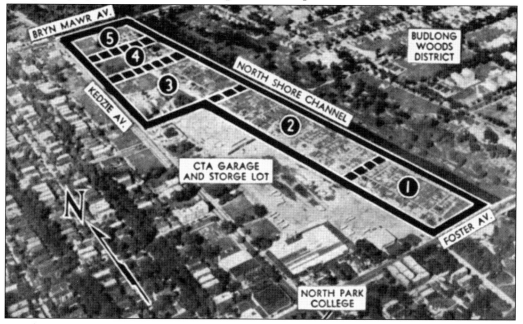

North Park College unsuccessfully attempted to lease 23 acres adjacent to the North Shore Channel (north of Foster Avenue) from the sanitary district for athletic fields in 1951. The complex would have had (1) tennis courts and parking, (2) a football field with removable bleachers surrounded by a quarter-mile track, (3) a baseball field, (4) practice fields, and (5) parking and a landscaped park along Bryn Mawr Avenue.

The 1956 master plan showed two new men's dormitories to be built near Burgh Hall. Other buildings on the south side of the river were married student housing on Spaulding Avenue and faculty apartments and a president's residence on the north side of Carmen Avenue. Three new women's dormitories and a student union would be built on Christiana Avenue by Sohlberg Hall. The library would be built north of Nyvall Hall, and a chapel

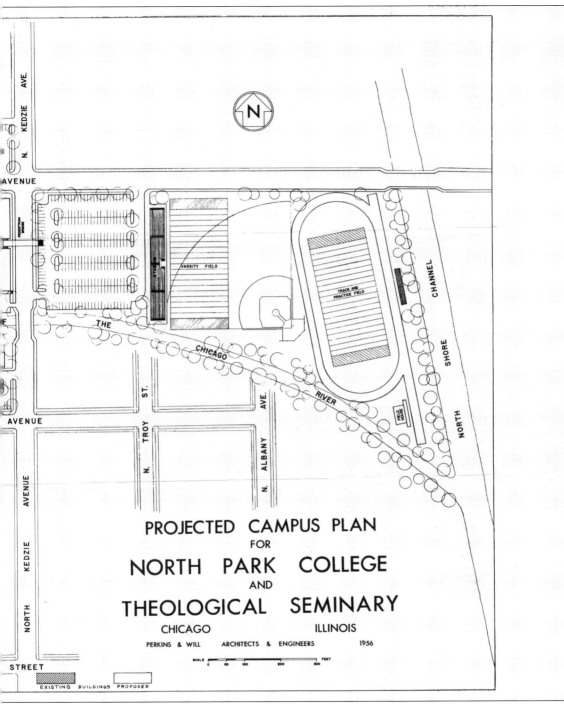

PROJECTED CAMPUS PLAN

FOR

NORTH PARK COLLEGE

AND

THEOLOGICAL SEMINARY

CHICAGO ILLINOIS

PERKINS & WILL ARCHITECTS & ENGINEERS 1956

SCALE
0 50 100 200 300 FEET

EXISTING BUILDINGS PROPOSED

would replace the Lundholm building. The existing gymnasium would be replaced by a new gymnasium-auditorium, and an athletic field would be added east of the campus. A large parking lot would be added east of Kedzie Avenue, and another parking lot would replace the open space in front of Wilson Hall and Hanson Hall. Wallgren Library and the new gymnasium were the only buildings in this plan that were actually built.

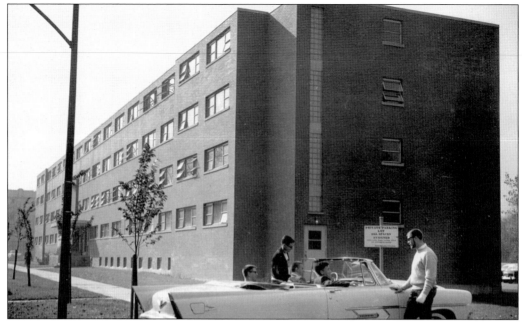

Burgh Hall, a men's dormitory named in honor of business manager J. Fredrick Burgh, opened in 1956. It was the first building North Park College constructed south of the river on the triangle of land the school purchased in 1954. Burgh Hall is now a coed residence hall due to an increase in the number of female students.

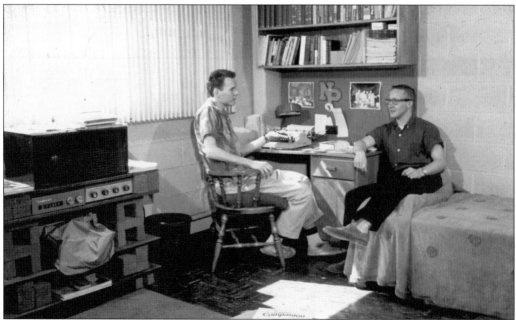

Burgh Hall provided housing for 208 men on four floors. Each of the rooms had tile floors, concrete block walls, and built-in desks, bookcases, and dressers. The only movable objects in the rooms were the beds and desk chairs. The dormitory was built with low 7-foot-8-inch-high ceilings because Chicago ordinances required buildings taller than 32 feet to install an elevator.

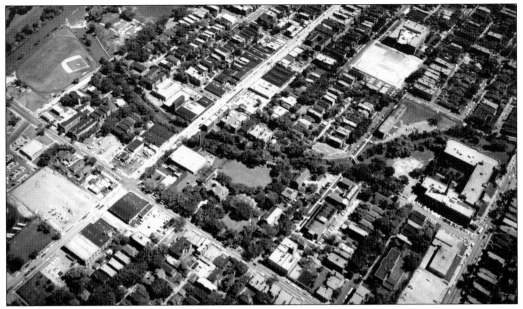

This aerial photograph of campus taken in 1960 shows the land North Park College acquired for an athletic field two blocks east of the campus. The combination football-baseball field, shown in the top left corner of the photograph, was surrounded by a two-lane, quarter-mile cinder track with an eight-lane straightway for sprints on the east side of the field (adjacent to the river). The field, located south of Foster Avenue and adjacent to the North Shore Channel, was ready for use in the fall of 1958. Removable bleachers (below) were installed on top of the track on the east side of the field before each football season and removed after the season ended.

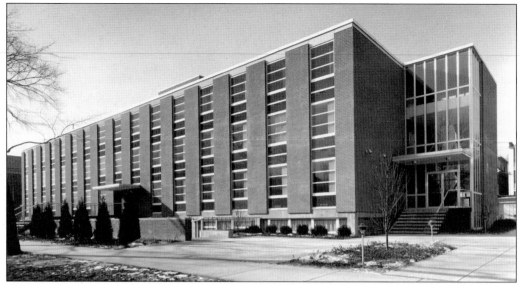

Wallgren Library, a four-story library and classroom building, opened in 1958. It was named in memory of Samuel Wallgren, the former dean of the academy and the college. The lower level had two classrooms, a projection room, a language laboratory, and faculty and student lounges. After Brandel Library was built, Wallgren Library was demolished in 2002.

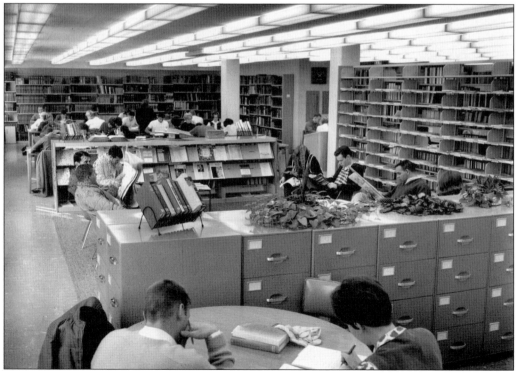

The college library occupied the first two floors and Mellander Library (the seminary library) moved from Nyvall Hall to the southern half of the top floor of Wallgren Library. The two spaces had a capacity of 75,000 volumes and could accommodate 275 students.

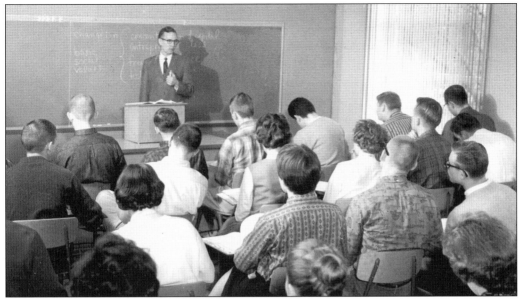

This 1963 image shows Prof. Quentin D. Nelson teaching in one of the classrooms that was located along with offices in the northern half of the building. Each floor had four classrooms and three faculty offices. The floors in this half of the building were built with the same steel support in the concrete floors as in the southern half to permit future expansion of the library into this area.

Students helped move the college library books from Old Main to Wallgren Library. The Old Main library was now exclusively used by the academy. The building in the background is Cedar House, the former John Leaf residence that was built in 1893 (see page 22). North Park College purchased this home in 1953 and used it for admissions and faculty offices. It was torn down in 1971.

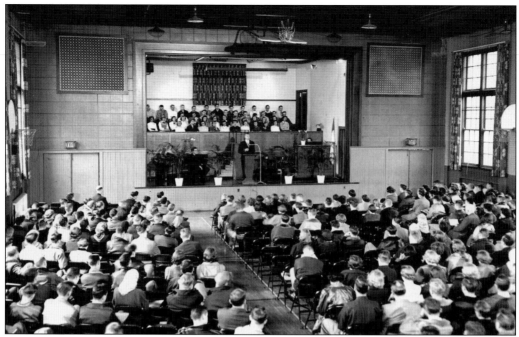

The old gymnasium was in constant use from early morning until late at night. It was used for chapel services, physical education classes, team practices, athletic events, and intramural activities by both the college and the academy.

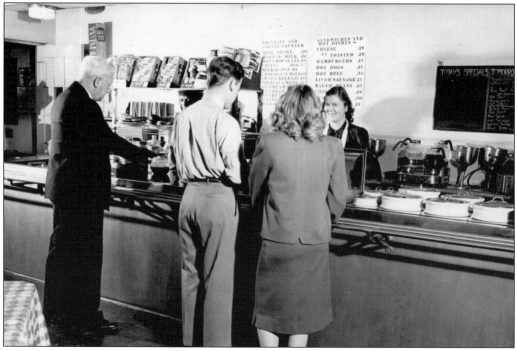

Academy students could purchase food in the cafeteria located in the lower level of the Lundholm building. The academy cafeteria moved from the basement of Wilson Hall to the Lundholm building in 1940.

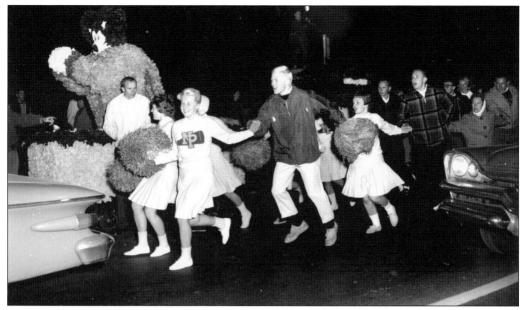

A snake dance, which slithered along Foster Avenue (above) and led students to a large bonfire and pep rally at the football field, was one of the school's many homecoming traditions. Other homecoming traditions included floats built by the students (below), a student-produced homecoming play or variety show, and the election of a homecoming king and queen.

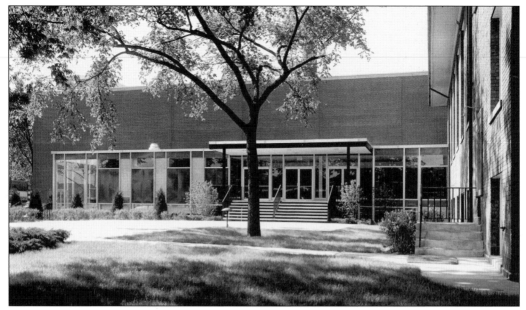

The new gymnasium opened in 1959. It was built on the corner of Foster and Kedzie Avenues and was attached to the rear of the old gymnasium (right). The gymnasium had a full-size basketball court on the upper level. It could also be used as an auditorium because there was a proscenium stage at the east end of the court.

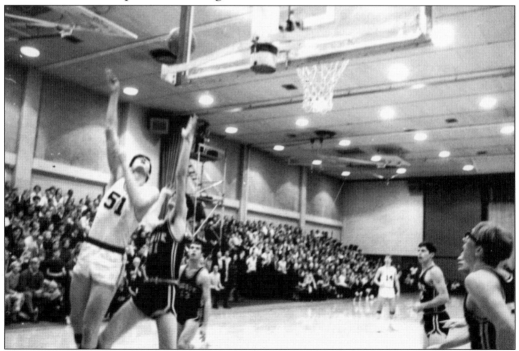

A capacity crowd watches a basketball game in the new gymnasium, which originally had a seating capacity of 1,400 for basketball games before additional bleachers were added in 1978. The capacity increased to 2,200 when removable seats were placed on the floor to use the room as an auditorium.

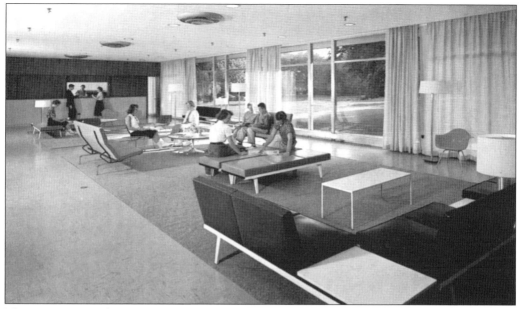

The gymnasium lounge on the west end of the upper floor of the gymnasium was a popular place for both on-campus and commuter students to relax or study between classes. The lounge was renovated in 2004 and renamed the Viking Café. It has three large-screen televisions and wireless Internet connections. The café serves gourmet coffee, bakery items, sandwiches, salads, and ice cream. (Author's collection.)

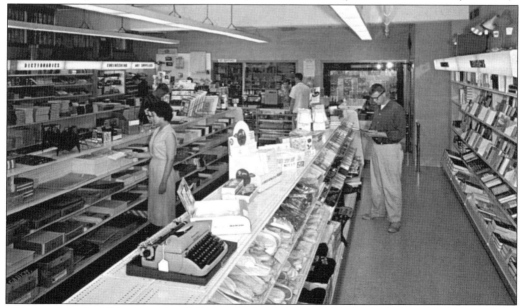

The campus bookstore moved from the basement of the Lundholm building to the west end of the lower level of the gymnasium. After the bookstore was replaced by the Covenant Press bookstore (later renamed Covenant Bookstore) in 1966, this room was used as a wrestling room from 1966 until 1985 and fitness center from 1987 until 2006. The bookstore returned to this room in 2006 after Covenant Bookstore closed. (Author's collection.)

Karl Olsson became the fifth president of North Park College and Theological Seminary and served from 1959 to 1970, a turbulent period of unrest on many college campuses. Olsson graduated from North Park Junior College in 1933 and North Park Theological Seminary in 1937. He was pastor at Covenant churches in Stillwater, Minnesota, and Chicago before he joined the North Park faculty in 1938. He was a decorated chaplain during World War II and taught at the University of Chicago before returning to North Park in 1948.

Donald Frisk was the dean of North Park Theological Seminary from 1961 to 1967. He graduated from the seminary and pursued graduate studies at Union Theology Seminary in New York City and the University of Chicago. He was pastor at Covenant churches in New Rochelle, New York, and Princeton, Illinois, before he was called to teach at North Park in the fall of 1945.

Four

GROWING PAINS

Karl Olsson became president of North Park College and Theological Seminary when Clarence Nelson became president of the Evangelical Covenant Church in 1959. The college achieved full accreditation from the North Central Association in 1961 without a probationary period that is required for most schools. The seminary achieved full accreditation from the Association of Theological Schools in 1963.

After the college was accredited, it applied for membership in the College Conference of Illinois and Wisconsin (CCIW), a prestigious athletic conference consisting of comparable-size colleges, and was accepted in 1961.

Changes were implemented to meet the needs of the increased enrollment. The old gymnasium was remodeled into a chapel after the new gymnasium opened in 1959. The Lundholm building was renovated as a women's dormitory and renamed Ohlson House. The seminary acquired an apartment building to provide housing for married students in 1964 and named it Lund House, in honor of Nils Lund. The campus center and Anderson Hall, a dormitory for women, were built adjacent to Burgh Hall and opened in 1965. Carlson Tower, a classroom building named in honor of martyred Covenant missionary Dr. Paul Carlson, and the lecture hall opened in 1967.

Neither tuition nor constituent support was adequate to cover the large debt payments required to pay for the expanded college curriculum and the building program of the 1950s and 1960s. The school reluctantly reduced expenses by closing the academy. The last academy class graduated in 1969, and Old Main and Wilson Hall, buildings used exclusively by the academy, were closed.

North Park College students wanted the school to eliminate required chapel attendance, allow dancing on campus, and expand dormitory hours to permit resident students to stay out later at night. The board of directors approved the changes in 1970. A limited open-dorm policy was initiated that allowed visitors of the opposite sex to visit dormitory rooms one evening a week. Additional evenings were gradually added, and by 1982, the dormitories allowed visitation seven evenings a week during limited hours. Some enrollment figures during this time are as follows:

Enrollment	1959–1960	1969–1970
Academy	399	330 (enrollment in 1968–1969)
College	859	1,316
Seminary	84	70
	1,342	1,716

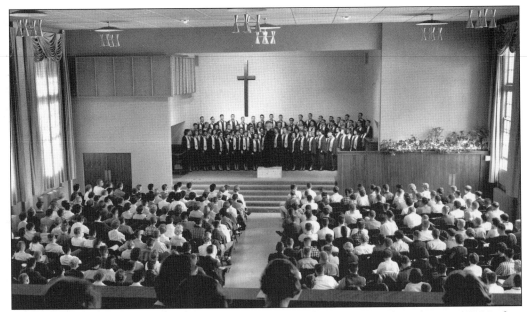

The old gymnasium was converted into a chapel for the college and academy in 1959 after the new gymnasium was built. The appearance of the room was altered as the ceiling was lowered, new lights were installed, and tile was installed over the wood floor to create an attractive worship environment (compare with the photographs on pages 29 and 62). Two years later, a $30,000 pipe organ with 1,700 pipes was added.

Beanies were required headgear for first-year students during freshmen initiation week in this 1960 photograph. Other rites included carrying books in wastebaskets, wearing pajamas to class, wearing clothes backward, and singing the school song. Freshmen were required to follow all reasonable orders given them by upperclassmen. Offenders were subject to punishment issued by a kangaroo court at the end of the initiation week.

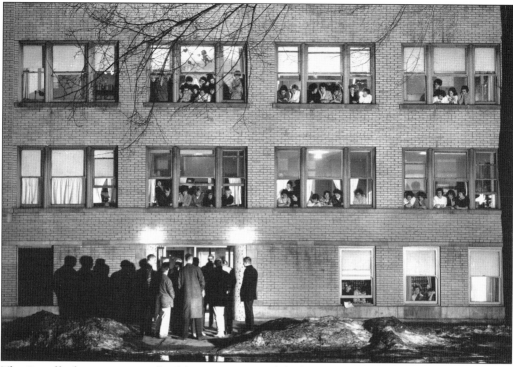

The Lundholm apartment building was remodeled into a dormitory for 135 women. It was renamed Ohlson House in honor of former North Park College president Algoth Ohlson. The dormitory has a single entrance located on the Spaulding Avenue side of the building (above). Fifteen apartments in the Spaulding Avenue wing of the building were converted into dormitory rooms during the summer of 1960. The remaining nine apartments in the Foster Avenue side of the building were converted the following summer. Each floor had four single rooms, four double rooms (below), and three triple rooms. Existing bathrooms were used for bath and shower combination rooms or as lavatories. A long, angling central hallway was installed on each floor that passed through former walls and bridged stairwells that no longer existed.

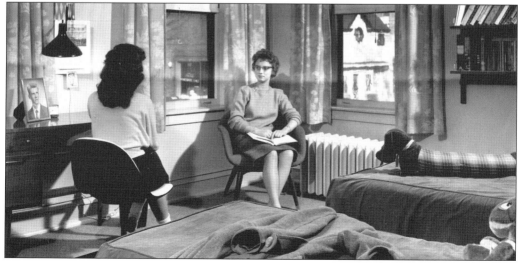

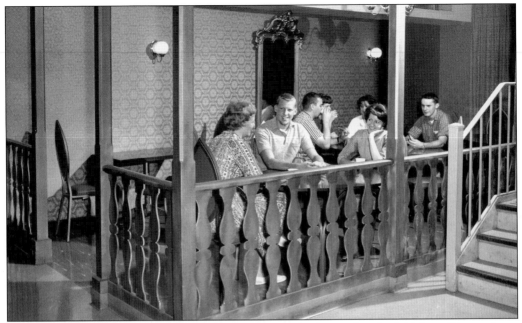

College students used the academy cafeteria on the lower level of Ohlson House for a snack shop and a lounge before the campus center was built in 1965. The "caf" was open on Monday through Thursday nights. This photograph shows students in the "caf" after it was remodeled and expanded during the summer of 1961.

Members of North Park College's first senior graduating class pose for a class picture in 1960. When the school began its transformation from a junior college to a four-year college two years earlier, the administration promised these students that if they returned to North Park for their junior and senior years, the school would offer all the classes they needed to graduate no matter how small the enrollment might be.

More Covenant students attended North Park College after it became a four-year school. The Swedish American heritage of North Park (and the denomination) is apparent in this 1961 photograph showing students who had the same last names. The number of Swedish American students would have been even greater if Ericksons, Isaacsons, Olsons, and Swansons had been included in the photograph.

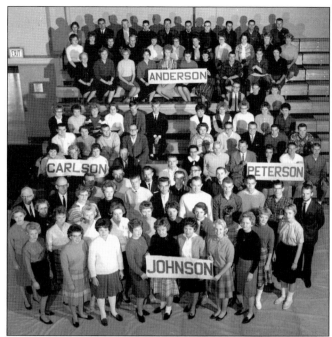

Physical education teacher Inez Olander and academy students prepare to cut a cake shaped like Old Main to celebrate the academy's 70th anniversary. Unfortunately the academy did not celebrate its 80th anniversary because it closed in 1969 because of increasing costs and declining enrollment. Enrollment declined by nearly 100 students during its last 10 years.

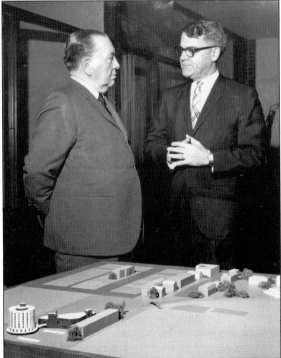

North Park College continued to add new buildings to meet the demands of increasing college enrollment during Karl Olsson's presidency. Plans for a proposed student union were displayed at a Friends of North Park dinner in 1963 (above). Olsson discusses North Park's development plans with Chicago's Major Richard J. Daley in the photograph at left as they stand next to a model of the campus in 1965. Daley (left) came to the campus to participate in the dedication ceremonies for Anderson Hall.

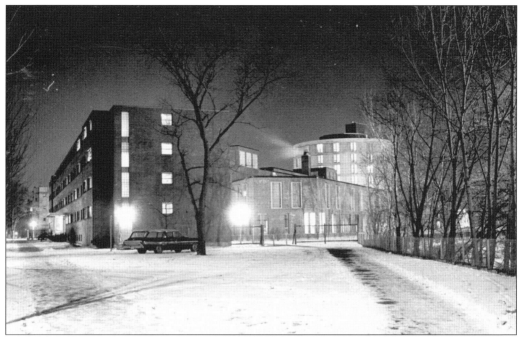

Magnuson Campus Center, named in honor of Raymond and Astrid Magnuson, was constructed in 1965. The student union originally had a snack shop with pool tables called the Cranny, lounges, a room where students played table games, a listening room with a stereo record player, a television room, a studio for campus radio station WNPC, and offices for the student association. There are eight motel rooms on the third floor.

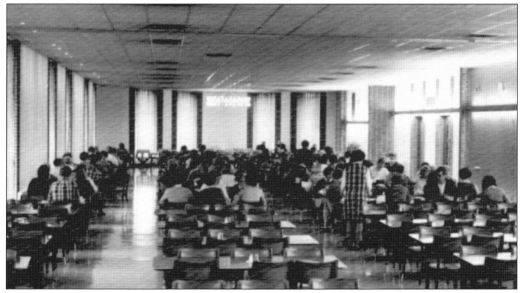

The dining hall is located on the second floor in Magnuson Campus Center. It seats 560 people and replaced the cafeteria that was located in Sohlberg Hall. The serving area originally had two separate serving lines. It was redesigned and enlarged in 1986 and now contains special areas for grilled foods, desserts, soup and sandwiches, breakfast foods, and beverages.

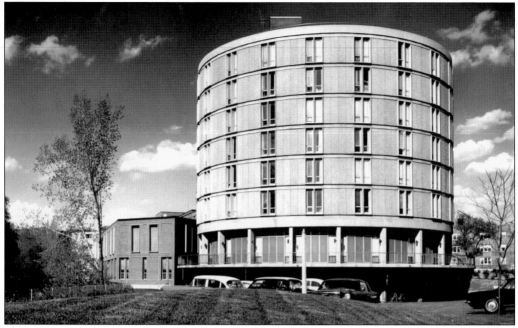

This photograph shows Magnuson Campus Center (left) and Anderson Hall (right). Anderson Hall is named in honor of Anna Anderson. The dormitory opened in 1965 and houses 216 women. Anderson's unique cylindrical shape was modeled after the famous Marina Towers in downtown Chicago. Originally all the showerheads in the restrooms were lower than five feet so women could take showers without getting their hair wet. The showerheads were raised to normal height in 1989.

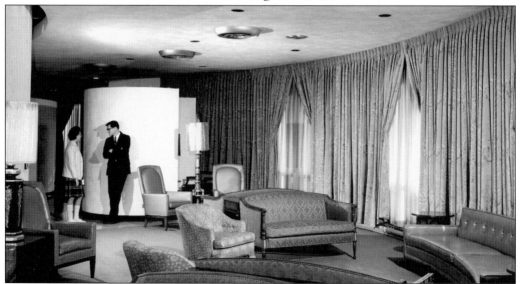

The man in this photograph is leaning against one of the two semiprivate lounges for couples in the Anderson lounge. These lounges were nicknamed "mushrooms" because they were places where couples could mush. By 1982, the open-dorm policy allowed men to visit the dormitory rooms seven evenings a week, and the mushrooms were no longer necessary. They were removed when the lounge was remodeled in 1988.

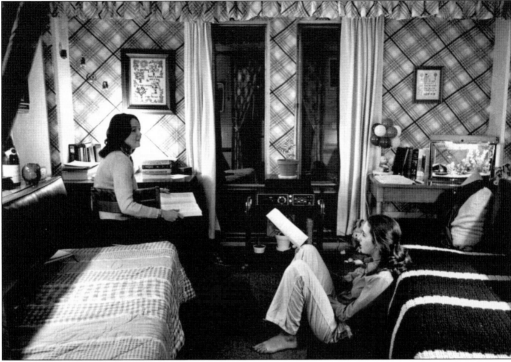

Anderson has pie-shaped dormitory rooms around the perimeter of each floor that encircle the center utility area that has an elevator, two stairways, two restrooms, and a laundry room. The beds in the rooms were on rollers so they could be rolled out at night and be used as a bed and rolled back against the wall under a padded storage cabinet during the day to be used as a sofa.

A 65-year-old campus landmark was removed in May 1966 when the original president's residence on the corner of Foster and Spaulding Avenues was torn down. The administrative offices that were housed in the building were moved to Caroline Hall, which was no longer used as a women's dormitory following the construction of Anderson Hall.

Lund House, a 27-unit apartment building on the corner of Spaulding Avenue and Argyle Street, was purchased in 1964. It was named in honor of former seminary dean Nils Lund. Two-and-one-half-, three-, and four-room furnished apartments were available for married seminary students and their families. The building is now used as a residence for undergraduate students.

North Park College initiated the nursing program in the fall of 1964, and the first four-year class graduated in June 1968. The program was accredited by the National League for Nursing in 1970. After North Park started the program, the board of directors at Swedish Covenant Hospital analyzed its nursing program. It voted to close its school of nursing and merge it with the college's program.

North Park College purchased the retail building on the northwest corner of Foster and
Kedzie Avenues in 1965 and leased it to Covenant Press, a Christian bookstore operated
by the denomination. Covenant Press (later renamed Covenant Bookstore) moved its
retail operations into the building and took over the operation of the campus bookstore.
Covenant Bookstore closed in 2006, and the campus bookstore moved back to the lower
level of the gymnasium.

Annual nominating conventions were held to select candidates for student association
presidency. Students formed delegations, many of which dressed in costumes, as shown
in this photograph. The conventions usually averaged 50 delegations and involved
approximately 350 students. Two candidates were selected at the convention and the
election was held the following week.

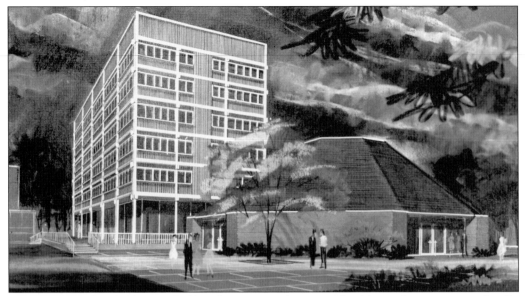

Initial designs for the lecture hall and a science-classroom building (above) were radically different than the buildings that were actually built (below). The Modine Learning Center was constructed on the back campus behind the gymnasium and opened in 1967. It consists of the six-story Carlson Tower classroom building, Wikholm Laboratories, and the lecture hall–auditorium. The complex is named in honor of Arthur Modine, a North Park College benefactor. His father, J. A. Modine, was the contractor who built Old Main in 1894. Carlson Tower is named in memory of Dr. Paul Carlson, a Covenant medical missionary in the Congo who was martyred in 1964. Wikholm Laboratories, the science laboratories located on the lower level of Carlson Tower, are named in memory of former chemistry teacher Donald Wikholm.

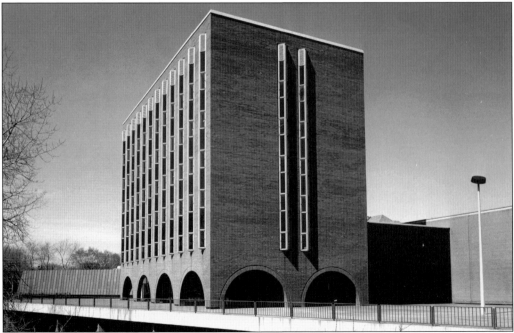

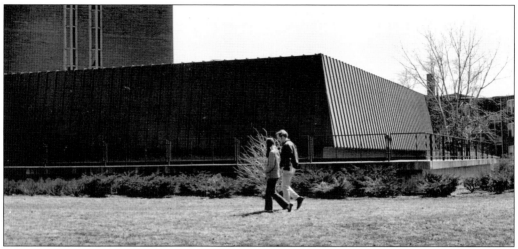

The lecture hall–auditorium has a copper-clad exterior. Throughout the years, hydration has gradually changed the original reddish-orange color of the copper to reddish-brown and bluish-green as the copper is exposed to the elements. The lecture hall is usually referred to as LHA by the students and is used for lectures, large classes, concerts, theatrical productions, and public events.

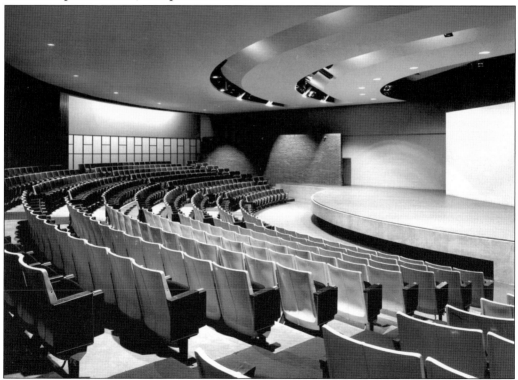

The lecture hall–auditorium seats 439 people. Films and backdrops for theatrical productions can be projected on the large permanent white screen at the rear of the stage. The building has an open thrust stage instead of a proscenium stage and was called a lecture hall instead of a theater to avoid additional construction expenses that were required to construct theaters under Chicago's building codes.

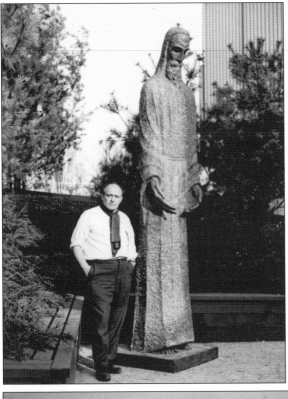

Learn of Me, a 10-foot bronze statue of Jesus Christ created specifically for North Park College in 1963 by Chicago sculptor Egon Weiner, was displayed at the 1964 New York World's Fair. The statue was moved to the campus in 1967 and displayed on the patio deck north of the lecture hall. It was moved to a more visible location at the east entrance of Anderson Chapel in 2000.

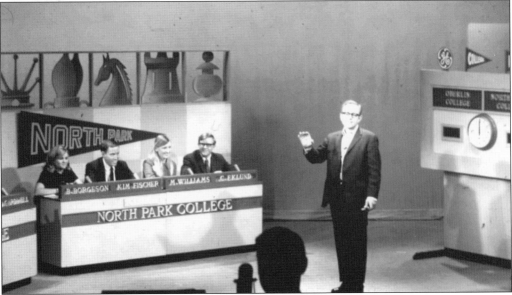

Bonnie Borgeson, Kim Fischer, Mary Williams, and Chuck Eklund represented the college on two successive Saturdays on NBC-TV's nationally telecast *College Bowl* in November 1968. They defeated Regis College of Colorado 190-135 but lost to Oberlin College the following week. The school received scholarship grants of $1,500 from General Electric and $1,500 from *Seventeen* magazine for its victory. It received a $1,000 consolation award the following week.

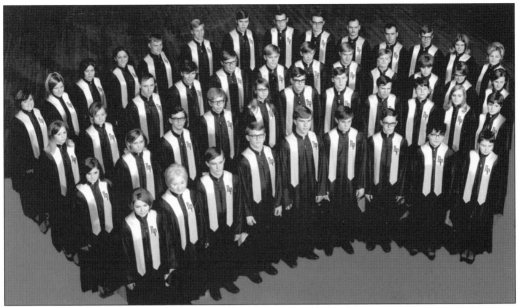

The men's and women's glee clubs were combined to form the college choir in 1938, and this photograph shows the 1969 choir, directed by David Thorburn. The choir went on annual concert tours and gained national prestige during the 1960s. North Park College's choir was one of two college choirs that were invited to join the Chicago Symphony Orchestra and Chorus in its performance of Gustav Mahler's Eighth Symphony in 1971.

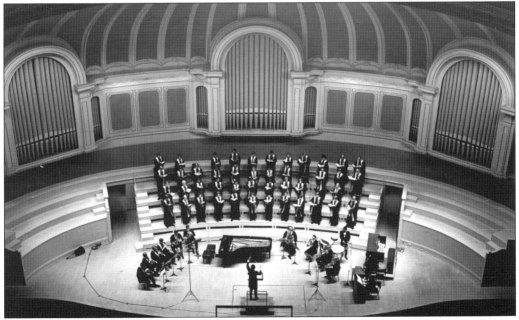

The 1969 college choir is shown performing in Chicago's Orchestra Hall, an annual tradition of the choir from 1947 to 2001. The concert was the choir's final performance of the year, and proceeds were used to raise money for college scholarships. Every alumnus who performed at the event was invited to join a multigenerational choir at the 50th anniversary of the choir in 1996, and 120 alumni participated.

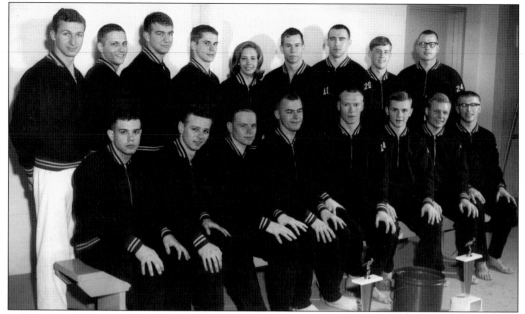

Freshman diver Pat Bateman (back row center) was a member of the 1964–1965 varsity swimming team. She became the first woman to win a varsity letter at North Park College, but she could not compete in the following years because the CCIW established a rule that prohibited women from competing on men's teams.

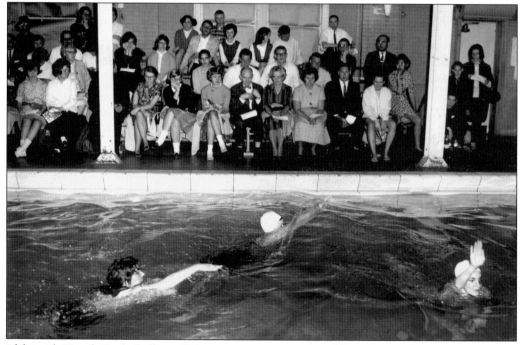

Although North Park College did not sponsor varsity athletic teams for women during this time, both the college and the academy sponsored synchronized swimming clubs for women. The women dressed in colorful costumes and swam choreographed routines when the clubs performed their annual water ballets in the school's swimming pool.

The American invasion of Cambodia in the spring of 1970 followed by the killing of four Kent State University students by National Guard troops resulted in protests and violence on many college campuses. North Park College president Karl Olsson addressed students at a convocation (right) and asked, "Would it embarrass you if I told you that I love you?" The students responded with applause. His speech eased tensions, and North Park College avoided the problems that occurred on other campuses. Following the convocation, a group of students marched down Foster Avenue to Covenant headquarters to request that the denomination take a moral stand on the crisis. Covenant president Milton Engebretson addressed the students (below) and said he would bring the matter up at the annual meeting of the denomination.

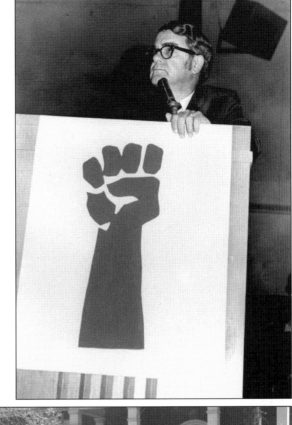

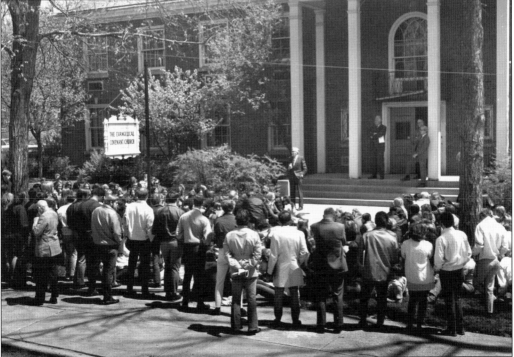

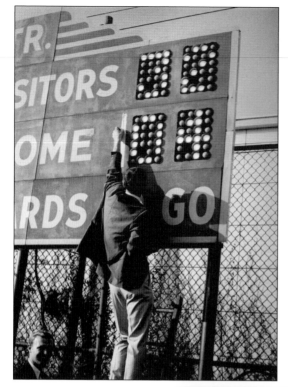

The *Chicago Tribune* called it the "Slaughter on Spaulding Avenue" when North Park College defeated North Central College 104-32 in the 1968 homecoming game. Student Dwight Nelson added tape to the scoreboard to show the score after North Park topped the century mark and set an NCAA College Division record for most points scored in a game. Quarterback Bruce Swanson broke another NCAA record when he threw 10 touchdown passes, 8 to Paul Zaeske. (Courtesy North Park University—Athletics.)

Linebacker Chuck Burgoon set a school record of 31 tackles against Carthage College in 1968. He had 507 tackles during his 27-game college career and was selected in the third round of the National Football League draft by the Minnesota Vikings in 1970. This photograph shows him signing a professional contract with Vikings general manager Jim Finks (left) as North Park College coach Chuck Emery watches in the background.

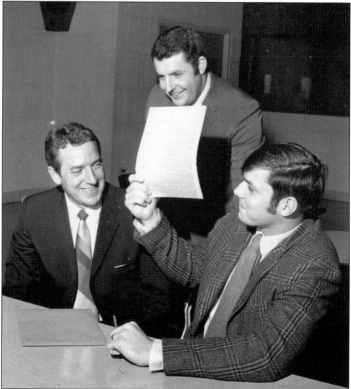

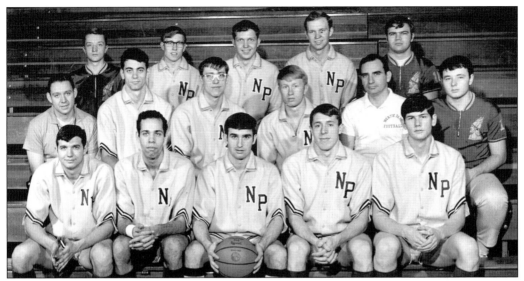

The NCAA selected North Park College's 1968–1969 men's basketball team to compete in its College Division Midwest regional tournament after the team won the school's first CCIW championship in any sport. Members of the team are, from left to right, (first row) Jim Carroll, Greg Crawford, Paul Rockwell, Paul Zaeske, and Rich Hoskins; (second row) coach Dan McCarrell, Dwight Nelson, Rich Swanson, Bruce Swanson, Jim Queen, and Gary Robinson; (third row) Bob Swanberg, John Olson, Larry Anderson, Jim Christopher, and Doug Swanson.

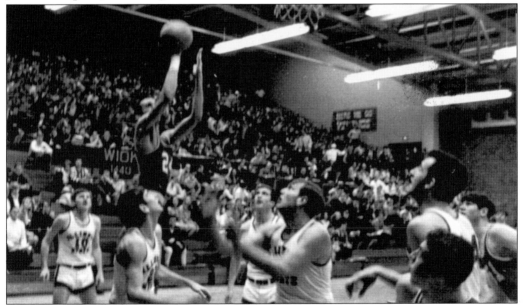

Greg Crawford shoots against Illinois State University in the NCAA tournament game. North Park College was eliminated after it lost the game 87-82. North Park finished in third place in the regional tournament after it defeated Concordia College (Chicago) 99-73 in the consolation game the following night. Crawford scored 53 points in the two games and was named to the all-tournament team. The North Park Vikings finished the season with a 21-5 record.

Lloyd Ahlem became North Park College and Theological Seminary's sixth president and served from 1970 to 1979. He was the first layperson to serve as president of North Park. Ahlem had been an administrator and professor at Stanislaus State College in California since 1962 and served on North Park's board of directors from 1966 until he was elected president in 1970.

Glenn Anderson served as dean of North Park Theological Seminary from 1968 to 1982. He was ordained by the Evangelical Covenant Church in 1953 and was pastor at Covenant churches in Malden and Attleboro, Massachusetts. He joined the North Park faculty in 1964 as assistant professor of church history. While he was dean, the enrollment of the seminary increased from a low of 57 students in 1971–1972 to 154 students in 1980.

Five

NATIONAL CHAMPIONS

Lloyd Ahlem was faced with financial challenges when he became North Park College and Theological Seminary's sixth president in 1970. The school made large expenditures to expand the curriculum and facilities to convert the college into a four-year school during the previous decade. These expenditures resulted in a $706,000 operating fund deficit and a long-term debt of $5.3 million by the time he assumed the office. During Ahlem's tenure, the school operated on balanced budgets, eliminated the operating fund deficit, and reduced the long-term debt to $2.1 million.

The composition of the college student body changed during Ahlem's tenure. Men traditionally outnumbered women and comprised 53 percent of the college student body during the 1960s. This changed in 1970, and by 1979, 57 percent of the college students were women. This increase in the number of women students was part of a national trend that occurred on most college campuses. This trend created a housing shortage at North Park College, and the school converted several apartment buildings it owned into student housing.

Seminary enrollment increased after the seminary began awarding master of divinity degrees to women in 1974. Women who attended the seminary prior to this change did not seek a degree. Additional women enrolled after the 1976 Covenant annual meeting voted to ordain women. By the fall of 1981, nearly 11 percent of the seminary students were women.

Wilson Hall was renovated and reopened in 1974 as a classroom and office building for the art and music departments. The building had not been used since the academy closed in 1969. The remaining classrooms and offices in Wallgren Library were vacated when Wilson Hall reopened. Wallgren Library was renovated in 1976 to utilize the entire building for library purposes.

North Park College's men's basketball teams won three consecutive NCAA Division III national championships in 1978, 1979, and 1980. Additional seats were added on the stage and in the corners of the gymnasium to handle the capacity crowds. Permanent bleachers and a four-lane, all-weather track were added at the athletic field.

Lloyd Ahlem resigned as president in 1979. The board of directors appointed Rev. Arthur A. R. Nelson as acting president and dean of students Carroll J. Peterson as director of administrative affairs to coordinate the day-to-day administration on campus until a new president was installed. Enrollment from the start of Ahlem's tenure to the end is as follows:

Enrollment	1969–1970	1979–1980
College	1,316	1,168
Seminary	70	150
	1,386	1,318

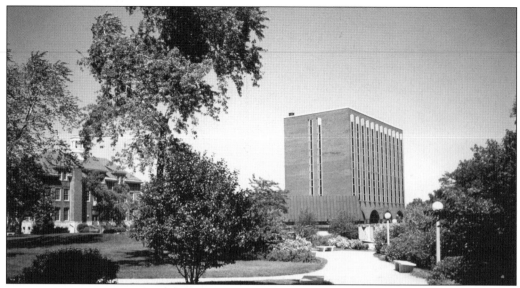

This view of the back campus looks east from Caroline Hall following the construction of Carlson Tower and the lecture hall–auditorium. The sidewalk along the North Branch between the lecture hall and Caroline Hall provided an unobstructed view of the river. The view gradually became restricted by the growth of trees and foliage along the riverbank.

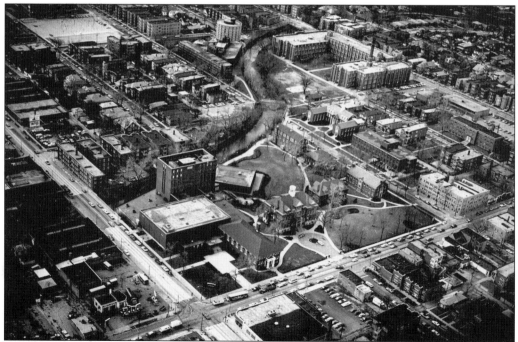

This aerial photograph of the campus from the early 1970s shows that the construction of the new gymnasium, Carlson Tower, and the lecture hall–auditorium consumed most of the open space in the back campus. It also shows the young trees that were planted in front of Old Main and Wilson Hall to replace the elm trees that died of Dutch elm disease. The photograph on page 48 was taken from a similar vantage point.

The college band added a marching band to its repertoire in 1964. It played during the halftime show at home football games. This photograph shows the marching band performing after it acquired uniforms in 1966. Members of the college band also played in pep bands during home basketball games.

Dancing was allowed on campus after the board of directors eliminated the prohibition against dancing in 1970. Prior to the change, "Swedish folk games," the school's designation for what is more commonly known as square dancing, was the only dancing that was allowed on campus. Unofficial school dances were occasionally held at off-campus sites.

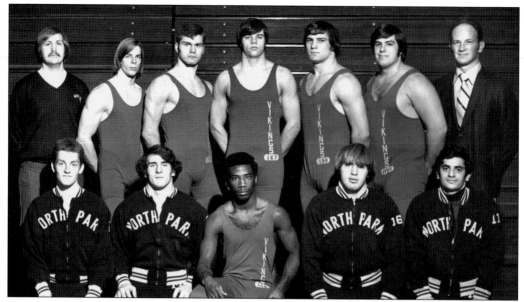

The 1972–1973 wrestling team won the CCIW championship. Members of the team are, from left to right, (first row) Brad Erickson, Mike Eremieff, Bob Davis, Tom Mietus, and Cary Peters; (second row) Doug Wilkins, Scott Hendricks, Joe Podraza, Jim Jensen, Ed Kress, Steve Cerese, and coach Rich Mahoney. North Park College organized its first wrestling team in 1962 but dropped the sport following the 1984–1985 season.

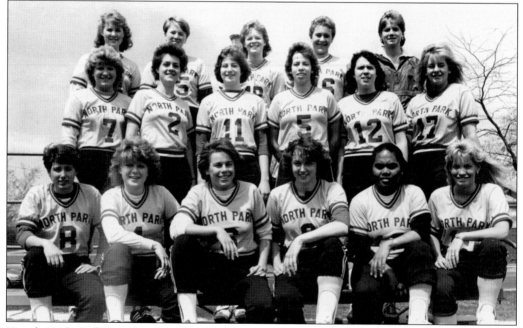

North Park College slowly added women's varsity athletic teams during the 1970s, beginning with volleyball during the 1969–1970 academic year. The school added women's varsity teams in basketball (1972–1973), tennis (1973–1974), softball (1975–1976), swimming (1976–1977), and track (1979–1980). The 1986 softball team (above) was coached by Rebecca (Johnson) Djurickovic.

Wilson Hall was vacated when the academy closed in 1969. It was renovated in 1974 to house the art department, portions of the music department, and academic offices. This photograph shows renowned Swedish American artist Lars-Birger Sponberg teaching an adult education art class in Wilson Hall.

When Wilson Hall reopened, it enabled the school to remove all the remaining classrooms and offices from Wallgren Library and use the entire building as a library. The library was closed during the summer of 1976 to remove the classroom and office walls so the space could be used more efficiently. The interior of the building was completely renovated, and new ceilings, lighting, and carpeting were installed. The library was rededicated on October 15, 1976.

Prof. Gregory Athnos organized the Chamber Singers in 1967. The small group of singers specialized in music from the medieval and baroque periods. Authentic instruments are used in its winter and spring campus concerts. Members of the 1977 Chamber Singers are, from left to right, (first row) Lee Ann Ekblad, Sharon Rich, Mary Maassen, Amy Axelson, and Karolyn Olson; (second row) Philip Rice, Lennard Zylstra, Gregory Athnos, and David Rice.

The 1970 Park Version gospel team was one of many gospel teams formed by students to perform on campus and in area churches. Each year the school selected one of the gospel teams to go on a summer tour and perform in Covenant churches throughout the country. Members of the Park Version are, from left to right, (first row) Jan Berry, Joe Anderson, and Leslie Herweg; (second row) Tim Fretheim, Joyce Nelson, Ted Erickson, and Mark Hunt.

One of the school's Christmas traditions is caroling in the Loop (downtown Chicago). Students ride the Brown Line "L" train to the Loop to sing Christmas carols on the streets and in various stores and buildings. This photograph shows students singing carols in 1977.

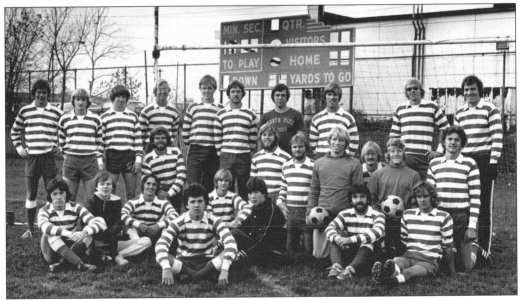

College and seminary students organized a soccer club team in 1971. The team was successful and was invited to join the Greater Chicagoland Soccer Conference in 1975. The undefeated 1977 team won the league championship with a 10-0-4 record. The University of Notre Dame's varsity team (16-1-1 record) agreed to play a challenge game against North Park College on April 29, 1978. North Park traveled to South Bend and defeated the Irish 1-0.

North Park College won three consecutive NCAA Division III basketball championships in 1978, 1979, and 1980. The teams were coached by Dan McCarrell (left), who compiled a record of 295-159 in 17 seasons as head coach and was named NCAA Division III Coach of the Decade in 1984. Bosko Djurickovic (right) became coach in 1984–1985 and won NCAA championships in his first and third seasons. He had a 196-79 record in 10 seasons.

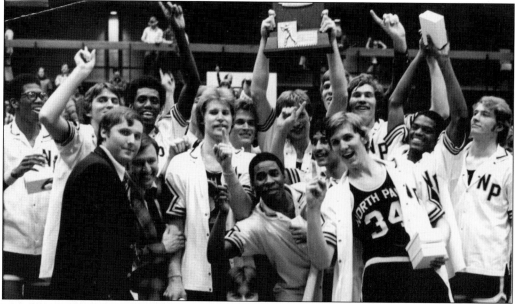

Members of the 1977–1978 basketball team celebrate after they defeated Widener College 69-57 to win the first of three consecutive national championships. The team finished the season with a 29-2 record. The 1978–1979 team had a 26-5 record, and the 1979–1980 team had a 28-3 record. During these three-peat championship seasons, North Park College defeated NCAA Division I foes Jacksonville University, the University of California–Irvine, and the University of San Diego.

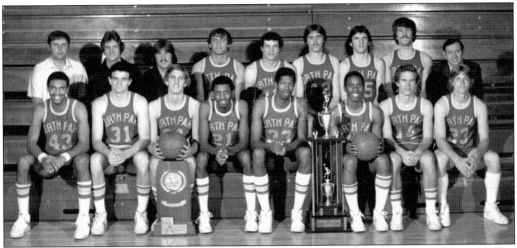

Members of the 1979 national championship basketball team are, from left to right, (first row) Keith French, Grant Grastorff, Jim Clausen, Modzel Greer, Mike Harper, Michael Thomas, Gregg Gierke, and Scott Groot; (second row), assistant coach Bosko Djurickovic, Brian McCaskey, John Wojdyla, Andy Farrissey, Bill Murphy, Mike Martin, Russ Bradford, Jerry Noreen, and head coach Dan McCarrell.

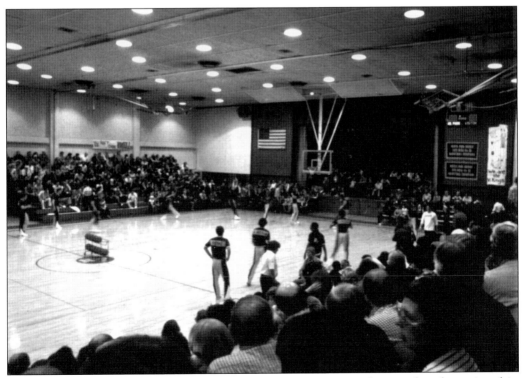

Capacity crowds packed North Park College's gymnasium during the championship seasons, and many games were standing-room only. This photograph shows the new bleachers that were added on the stage and in the four corners of the floor behind the baskets in 1978 that increased the seating capacity by 430 seats. (Author's collection.)

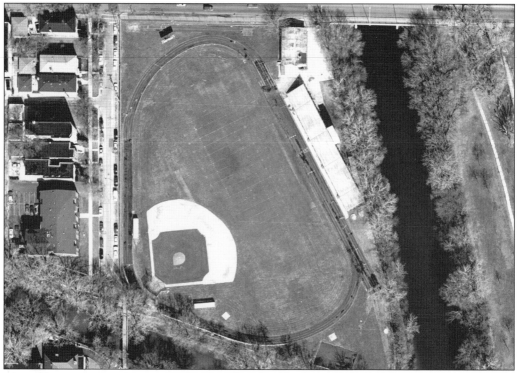

The old gas station along Foster Avenue was removed so the school could enlarge and reconfigure the athletic field (compare with the aerial photograph on page 59). Permanent bleachers were installed in 1978, and a four-lane, hard-surfaced track was added in 1979. Unfortunately the baseball field had short dimensions in both center (295 feet) and right (290 feet) fields.

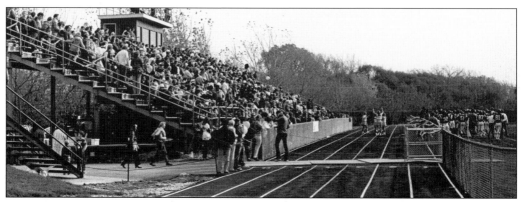

A capacity crowd fills the bleachers during a football game in 1979. The four-lane track had two additional lanes in front of the bleachers that were used for sprints. The athletic field was named Hedstrand Field in honor of Ted Hedstrand, who formerly coached in the academy and the college.

The school wanted to build a $6 million physical education and life fitness center at the corner of Foster and Kedzie Avenues. It would be a joint venture with the cardiac rehabilitation center at Swedish Covenant Hospital. The building site included the old gymnasium (which would be torn down). The building would have been attached to the present gymnasium and included a swimming pool, indoor track, basketball courts, and other athletic facilities.

A task force was appointed in 1978 to determine the best location for the school. It considered a 100-acre site in suburban Grayslake that is currently part of the Rollins Savanna Forest Preserve. The task force estimated it would cost $37.5 million to construct and furnish buildings equivalent to those on the existing campus. The cover of the September 1980 issue of the alumni magazine the *Northparker* indicated the school would remain in Chicago.

William Hausman served as president of North Park College and Theological Seminary from 1980 to 1986. He was ordained by the Evangelical Covenant Church in 1971 and was the associate dean at Trinity Evangelical Divinity School before he came to North Park. Hausman entered office during a time when colleges faced the challenge of high inflation and a decreasing number of high school graduates.

Robert Johnston was dean of North Park Theological Seminary from 1982 to 1993. He was the first dean who had not taught in the seminary before he was called to serve as dean. He also served as the school's first provost from 1988 to 1993.

Six

STAYING IN CHICAGO

The 1980 Covenant annual meeting made two important decisions: it called William Hausman as the seventh president of North Park College and Theological Seminary and approved the location task force recommendation that North Park College remain in Chicago and upgrade its campus.

The task force was formed in 1978 to determine whether North Park College should upgrade its campus or move to a new location to make the school more attractive to its constituency. It looked at various alternatives and considered moving the school to a 100-acre site in suburban Grayslake. Although cost and affordability were factors in the decision, it determined that North Park's present location made the school distinct. Rather than becoming one of the many evangelical Christian colleges located in the suburbs, it decided North Park should continue to be one of the few evangelical Christian colleges in the United States that was located in a major city.

North Park College's board approved a $31.6 million master plan that would place classroom buildings in the center of the campus, fine arts facilities on the west end, athletic facilities on the east end, and housing on the south end. The school began acquiring additional property in these areas. The existing buildings would be renovated, and three new buildings would be built: a recreation center at the corner of Foster and Kedzie Avenues, a center for Scandinavian studies between Wallgren Library and Ohlson House, and a chapel on the east side of Christiana Avenue behind Nyvall Hall. None of these buildings were constructed.

Old Main was completely renovated at a cost of $2.2 million and reopened as an administration building in the fall of 1986. Funds received from the Covenant Century Two Campaign were used to renovate other buildings and improve the appearance of the campus.

An extension program was set up at St. Augustine's College, a bilingual junior college, in the fall of 1981. The program was discontinued in 1984. Bilingual extension centers in the Uptown, Little Village, and Logan Square neighborhoods were initiated in 1983 in cooperation with the Chicago Metropolitan Development Board of Higher Education. The centers were transferred to Roosevelt University on July 1, 1990, in order to focus on strengthening the traditional campus-based college and seminary enrollment.

William Hausman resigned as president in 1986, and vice president Patrick Lattore served as acting president for one year.

Enrollment decreased when the baby boom ended and the number of high school graduates began to decline in 1979. Enrollment in the college dropped from 1,214 in 1981 to 770 in 1989. Enrollment for the years 1979–1980 and 1984–1985 is as follows:

Enrollment	1979–1980	1984–1985
College	1,168	1,059
Seminary	150	142
	1,318	1,201

When the school celebrated its 90th anniversary, students and Prof. Elder Lindahl built a gazebo for the May Day festival. Gray shingles were installed on the roof, and the base of the gazebo was bolted into the ground in the fall of 1982, when the school decided to make the gazebo a permanent part of the campus. The gazebo is a popular gathering place for informal classes, musical events, engagements, and wedding pictures. (Courtesy Office of External Relations, North Park University; photograph by Eric Staswick.)

North Park University celebrates the traditional Swedish holiday of Sankta Lucia by crowning a Sankta Lucia queen who wears the crown of candles during the traditional Lucia festival hosted by the Scandinavian department and the Center for Scandinavian Studies. The center is the earliest-formed cultural center at the university and runs the successful exchange program with Södra Vätterbygdens Folkhögskola in Jönköping that began in 1978.

Old Main was added to the National Register of Historic Places in 1982. The building was not used by North Park College after the academy closed in 1969 and was rented to Oak Therapeutic School from 1971 to 1981. The interior was gutted, and the building was totally renovated between 1985 and 1986.

Following the $2.2 million renovation, Old Main reopened as North Park College's administration building in 1986. North Park's acting president Patrick Lattore (left) and former president William Hausman (right) listen as Illinois governor James Thompson speaks at the dedication.

Former president Jimmy Carter addresses the audience at the April 16, 1986, dedication of a Habitat for Humanity house North Park College students helped rebuild in the Uptown neighborhood. It was North Park's second Habitat project in the city directed by Jim Lundeen. Former first lady Rosalynn Carter and Chicago mayor Harold Washington are on the left of the photograph.

The school used funds from the denomination's Century Two capital funds campaign to remodel buildings and improve the appearance of the campus. Three school-owned bungalows behind Nyvall Hall were demolished to create a small park on the west side of the campus with a curving sidewalk between the alley and Christiana Avenue. (Author's collection.)

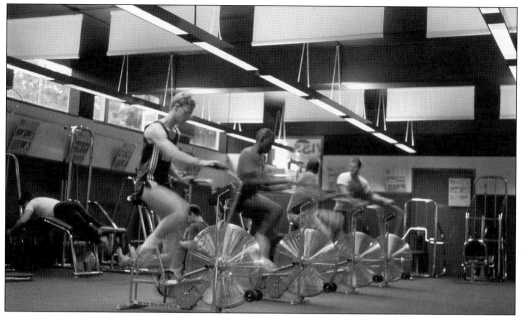

A new fitness center was opened on the lower level of the gymnasium in 1987 in the former campus bookstore (compare with the photograph on page 65). The room had been used as a practice room for the wrestling team from 1966 until the wrestling program was discontinued in 1985.

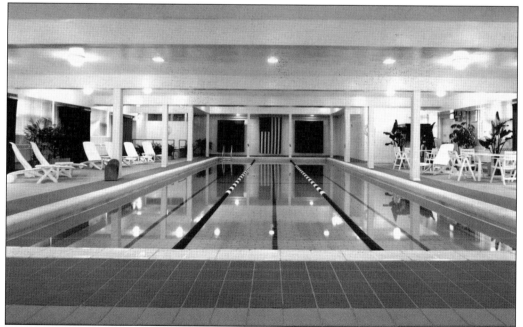

The swimming pool on the lower level of the old gymnasium was renovated using funds from the denomination's Century Two Campaign (compare with the photograph on page 29). The pool was the oldest indoor swimming pool in Chicago when it was replaced by the men's varsity locker room in 1999. Funds from the drive were also used to renovate the chapel (the old gymnasium), Ohlson House, and the dining hall.

Bosko Djurickovic coached the school's baseball teams from 1978 to 1994 and compiled a 331-293-3 record. His teams won the CCIW championship and appeared in the NCAA regional tournaments in 1983, 1984, 1987, 1988, and 1990. The photograph above shows the 1984 team.

The 1987–1988 women's basketball team became North Park College's first women's team to win a CCIW championship and the first team to participate in the NCAA Division III regional tournament. The team was coached by Rebecca (Johnson) Djurickovic, the wife of men's basketball coach Bosko Djurickovic. Members of the team included Janice Swanson, Susan Swanson, Terry Haller, Barb Dunn, Dibbit Oudal, Jane Stahl, Deborah Howard, and Tracey Faulkner.

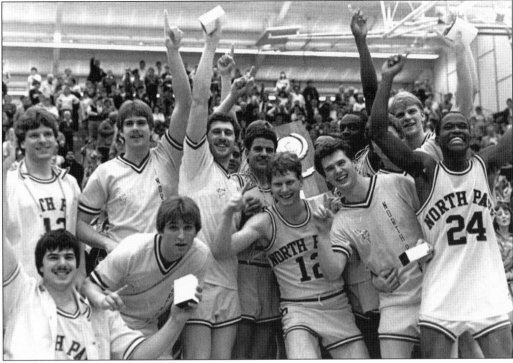

The 1984–1985 men's basketball team won its fourth NCAA Division III championship by defeating State University of New York at Potsdam 72-71. In the quarterfinals, North Park College defeated the nation's No. 1 ranked team, Wittenberg University of Ohio, by a score of 73-71. North Park completed the regular season with a 22-4 record, and first-year coach Bosko Djurickovic was named Coach of the Year by *Basketball Times* magazine.

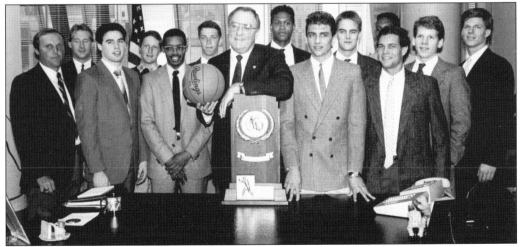

Illinois governor James Thompson congratulates the 1986–1987 championship team at the State of Illinois Center. Thompson graduated from North Park Academy in 1953. Pictured are, from left to right, head coach Bosko Djurickovic, assistant coach Mark Pytel, Bill Kraits, Al Navarro, Wade Seiffer, Ralph Houck, Gov. James Thompson, Mike Starks, Mike Barach, Todd Mitchell, Myron Starks, Todd Gierke, Matt Edstrom, and Henrik Gaddenfors. This was North Park's fifth NCAA title in 10 seasons.

David Horner, the first non-Covenanter to lead the school, served as president of North Park College from 1987 to 2004. He previously served as president of Barrington College from 1979 to 1985. He was just 29 years old when he became president of Barrington and was the youngest college president in America.

John E. "Jay" Phelan Jr. became dean of North Park Theological Seminary in 1996. He was the executive director of Covenant Publications before he was called to the position and previously served as pastor at Covenant churches in Coral Springs, Florida, and Salina, Kansas. Under his leadership, the seminary enrollment increased from 154 in 1996 to 274 in 2007. (Courtesy Office of External Relations, North Park University.)

Seven

NORTH PARK UNIVERSITY

David Horner became the eighth president of North Park College and Theological Seminary in 1987. During his 17-year tenure that ended in 2004, the decline in the college enrollment was reversed, and enrollment climbed to record highs as the student body became more racially and ethnically diverse. Centers for Korean studies, Latino studies, African American studies, and Middle Eastern studies were created to assist students from those cultural backgrounds and promote cultural unity on campus.

Total enrollment in the institution doubled as adult degree completion programs and graduate programs in business, nonprofit management, nursing education, community development, and music were created. With the addition of graduate programs, the school changed its name to North Park University in 1997.

Nearly 45 percent of the college students volunteered for one or more types of urban outreach ministry to serve poor and needy people in the Chicago area. The After Hours program at Albany Park Multicultural Academy received a President's Service Award in 1996, the highest honor given by the president of the United States for volunteer service. It was among 20 programs selected from 3,200 nationwide nominations.

Successful capital fund campaigns enabled the school to increase its endowment, reduce debt, improve facilities, and add new buildings. The $3 million Anderson Chapel was constructed in 1995 and was the first new building on the campus in 30 years. Brandel Library was built in 2001, replacing Wallgren Library. An attractive pedestrian mall was created in the center of the campus in 2002 after Wallgren Library was demolished, and both Spaulding Avenue and the alley behind Nyvall Hall were removed.

A new soccer field and track were constructed in West River Park in 2000. The new track enabled the school to remove the track at the athletic field. The field was reconfigured with artificial turf, lights, and new bleachers and was renamed the Holmgren Athletic Complex.

Enrollment during this time period steadily increased.

Enrollment	1984–1985	1994–1995	2004–2005
Traditional Undergraduates	1,059	1,029	1,408
School of Adult Learning	*	202	371
Graduate	(began 1991)	232	595
Seminary	142	158	271
	1,201	1,621	2,645

*Began in 1988. Extension classes totaled 153 in 1984.

North Park College celebrated its centennial in 1991 and art student Colin Walsh painted a depiction of Mount Rushmore with the heads of North Park presidents Karl Olsson, Lloyd Ahlem, William Hausman, and David Horner. Rick Carlson and Bob Stromberg wrote an original musical, *Old Main: A Love Story*. Set against the facade of Old Main, it used a multimedia presentation, familiar music from the past, and original songs to recount the history of the school.

North Park College's senior administrative team celebrates the college's inclusion as one of the region's top colleges in the October 1991 edition of *U.S. News & World Report*. From left to right are seminary faculty dean Klyne Snodgrass, college dean Dean Ebner, college president David Horner, college vice president Carl Balsam, and dean of students Edward Eddy.

Freshman Michelle Thomas (above) started the gospel choir as a student-led activity (and not an official school organization) in October 1993. The choir began with 15 students, grew to 35 by the end of the year, and had 60 students the following year. It became part of the music department in 1996 when Rollo Dilworth was hired as director and has as many as 200 participants each year.

A. Harold and Lorraine Anderson donated $3.5 million to the school to build a new chapel. Anderson Chapel opened in 1993. The building's curved sides increase seating capacity on the main floor. Architectural continuity with Hanson Hall was achieved by using the same color brick and connecting the two buildings with a glass narthex. (Courtesy Joanna Wilkinson.)

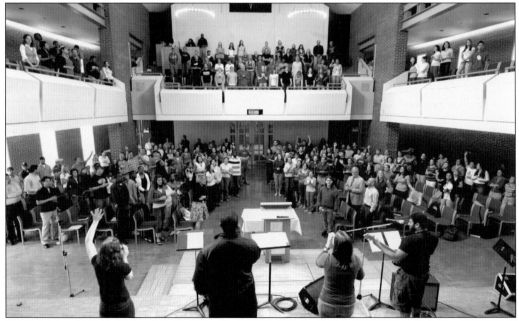

Anderson Chapel has a seating capacity of 254 on the main floor, 190 in the balcony that encircles the main floor, and 56 in the choir loft. The chapel includes the Magnuson pipe organ, which has a unique blend of 3,116 new and used organ pipes. Many of the used pipes came from the former First Covenant Church in Los Angeles. (Courtesy Office of External Relations, North Park University; photograph by Eric Staswick.)

Brandel Library is named in honor of Paul and Bernice Brandel. The 70,000-square-foot facility has a book capacity of 300,000 volumes and a seating capacity of 350 with additional seating in conference and study rooms. The building has gallery and exhibit space and archive storage and houses campus media services with a production laboratory. (Author's collection.)

In contrast to the classical exterior style of Brandel Library, the interior is modern with open ceilings and exposed ductwork. Workstations are linked to the campus computer network, and a wireless network access allows laptop computers to be used anywhere in the building. The library opened on August 27, 2001, and was dedicated on October 5. (Courtesy Joanna Wilkinson.)

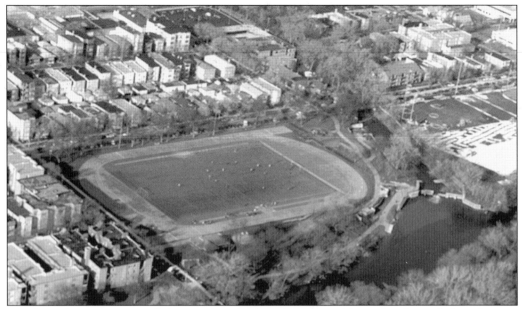

North Park University collaborated with the Chicago Public Schools and the Chicago Park District to build an artificial turf soccer field surrounded by a 400-meter track in West River Park in 2000. The field is used by North Park University's track and soccer teams and is located directly south of North Park's Holmgren Athletic Complex. (Courtesy FieldTurf.)

The new soccer field and track in West River Park enabled North Park University to eliminate the old track and reconfigure its athletic field with new bleachers, lights, and an artificial turf field for football, soccer, softball, and baseball (compare with the photograph on page 96). The complex was named the Holmgren Athletic Complex in honor of Mike and Kathy Holmgren although the football field retained the name Hedstrand Field. (Courtesy FieldTurf.)

A women's crew team was added as a varsity sport in 2003. It won a bronze medal at the Midwest championship in 2004 and a gold medal by finishing first at the Dad Vail Regatta, the largest collegiate regatta in the United States. The team returned to win a silver medal at the Dad Vail Regatta in 2005 and a bronze in 2006. There is also a men's crew team that competes as a club sport. (Courtesy Office of External Relations, North Park University; photograph by Eric Staswick.)

The 2005 men's soccer team celebrated its second consecutive CCIW championship. The team, coached by John Born, won CCIW titles in 2004, 2005, and 2006 and appeared in the NCAA Division III regional tournament in 2005 and 2006. Men's soccer became a varsity sport at North Park University in 1981. (Courtesy Office of External Relations, North Park University; photograph by Eric Staswick.)

The school acquired all the homes and apartment buildings on the north side of Carmen Avenue between Spaulding and Kedzie Avenues for additional student housing and future campus expansion. Many students preferred living in the school-owned apartments instead of the dormitories. (Courtesy Office of External Relations, North Park University; photograph by Eric Staswick.)

The school purchased Park North, a recently renovated apartment building south of Argyle Street, for $2.5 million in 2004 for additional student housing. The three-story building on the west side of Kedzie Avenue has a 24-hour front desk and a lounge. It opened in the fall of 2005 and houses 72 students in 36 studio apartments. (Courtesy Joanna Wilkinson.)

The appearance of the campus was radically transformed when Wallgren Library was torn down, Spaulding Avenue and the alley behind Nyvall Hall were removed, and the entire area was landscaped to create an attractive pedestrian mall through the center of the campus in 2002. Landscape architect Douglas Hoerr designed the area to reflect the distinctive character of the university and used native midwestern grasses and over 100 new trees to provide intimate, sheltered areas for students to meet, study, and relax. These photographs show how the project changed the appearance of Nyvall Hall (above) and Caroline Hall and the student services building (below). (Above, author's collection; below, courtesy Linda Oyama Bryan.)

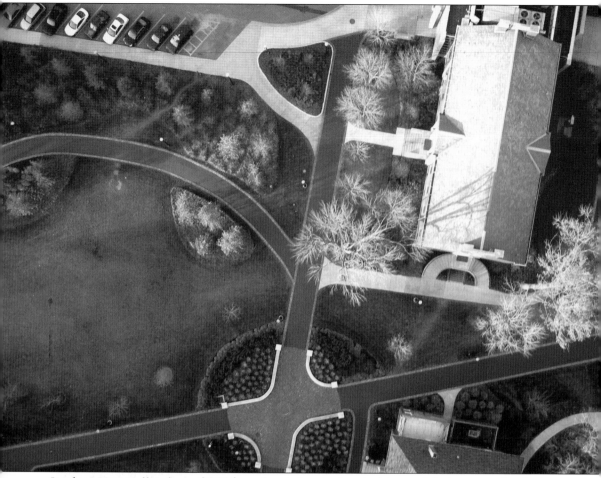

Student Matt Kelly, class of 2006, undertook a project in kite aerial photography during his senior year. This vantage point is far enough away to capture pathways and structures of the newly landscaped campus yet close enough to reveal details of the plants and brickwork. The photographs were featured in an exhibition in the Carlson Tower art gallery. Above is Hanson Hall, the compass, and green space created when Wallgren Library was torn down. (Courtesy Matt Kelly.)

The relandscaped pedestrian mall created an open space in the center of the campus that extends from the gymnasium on the east side of the campus to Brandel Library and Sohlberg Hall on the west. The sidewalk connecting the gymnasium to Brandel Library (right) is longer than two football fields. New sidewalks were installed along the river and behind Caroline Hall (left) and the student services building (center). (Courtesy Office of External Relations, North Park University.)

A 1972 photograph (left) looking north from Carmen Avenue shows a muddy, undeveloped lot in the foreground. The alley behind Nyvall Hall and Wallgren Library was lined with garages and telephone poles. The area today (right) was transformed into a pleasant gateway to the western part of the campus. The pillars by the sidewalk are modeled after the pillars in front of Old Main. (Right, courtesy Joanna Wilkinson.)

Wallgren Library was built on the west side of Spaulding Avenue in 1958. This photograph is unique because parked cars usually cluttered both sides of the street. Wallgren was vacated when Brandel Library opened in 2001 and was razed the following year. The building was used just 44 years and was the second building constructed by North Park University that was ultimately removed. The original president's residence was demolished in 1966.

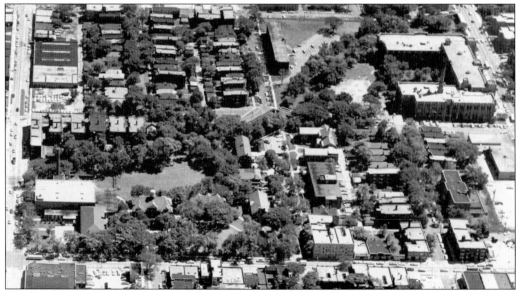

This campus aerial photograph from 1960 shows Sohlberg Hall surrounded by apartment buildings and bungalows. Sohlberg was isolated from the remainder of the campus because Nyvall Hall, Wallgren Library, and Ohlson House formed a virtual boundary along the west side of Spaulding Avenue.

This photograph was taken from the same location after Wallgren Library was torn down and a large green space was created in the center of the campus. Nyvall Hall is on the left side of the photograph, and Brandel Library is on the right. (Author's collection.)

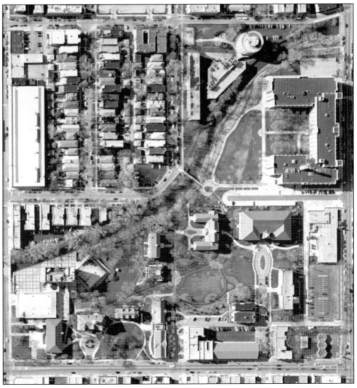

This aerial photograph from 2007 shows the virtual boundary was eliminated when Wallgren Library was torn down. Sohlberg Hall and Brandel Library are located on the west end of the new pedestrian mall. Helwig Recreation Center is on the upper left side of the photograph. (Courtesy Aero-Metric.)

David L. Parkyn was installed as North Park University's ninth president in 2006. Parkyn was provost and senior vice president at Elizabethtown College in Pennsylvania from 2004 to 2006. Prior to his work at Elizabethtown, he spent 23 years at Messiah College where he filled several positions, including senior vice president, vice president for planning, director of general education and assessment, and professor of religious studies. (Courtesy Office of External Relations, North Park University.)

The North Park University senior administrative team from 2007 is seen here. From left to right are (first row) David L. Parkyn and Joseph Jones; (second row) John E. "Jay" Phelan Jr., Carl E. Balsam, Andrea E. Nevels, and Daniel W. Tepke. (Courtesy Office of External Relations, North Park University.)

Eight

WHAT'S PAST IS PROLOGUE

When David Horner resigned as president in November 2004, board chair Bruce Bickner was named acting chief executive officer and John E. "Jay" Phelan Jr., Carl E. Balsam, and Daniel W. Tepke were appointed as the Office of the President leadership team to manage the school until the new president assumed office. During the interim period, the school purchased Sawyer Court Residences, a recently renovated 28-unit condominium at the southeast corner of Sawyer Avenue and Argyle Street in 2006 for additional student housing. The $12.5 million Helwig Recreation Center was constructed at the southwest corner of Kedzie and Carmen Avenues and opened in the fall of 2006.

David L. Parkyn was installed as North Park University's ninth president in 2006. Burgh Hall was completely renovated during the summer of 2008, and the school developed plans to add a new student services and classroom building.

North Park adopted the slogan What's Past Is Prologue when it celebrated its 75th anniversary in 1966, but that slogan seems just as appropriate today. Many changes have occurred since North Park first opened its doors in 1891. The Swedish-speaking school that started in Minneapolis is now a racially and ethnically diverse urban university in Chicago. Students of color now represent a third of the undergraduates, and the proportion is higher in the adult and graduate programs. New buildings were added and the boundaries of the campus expanded. The cabbage patches and cornfields surrounding the campus have been replaced by stores, bungalows, and apartment buildings. Many changes have occurred, and what's past is just a prologue to additional changes that will occur in the future.

Despite all the changes, the school retains David Nyvall's original vision: North Park is a Covenant university with a college and seminary that offer general education courses in a wide range of disciplines taught in a Christian context.

Enrollment figures from recent years are as follows:

Enrollment	2004–2005	2007–2008
Traditional Undergraduate	1,408	1,882
Adult Undergraduates	371	409
Graduate	595	720
Seminary	271	274
	2,645	3,285

North Park University's jazz band was organized in 1983 and has become one of the most popular musical groups on campus. This photograph shows Joe Lill (center) with the 2006 jazz band. Lill, who became director of the jazz band in 1988, has also been director of the wind ensemble since 1992. (Courtesy Office of External Relations, North Park University.)

David L. and Linda Parkyn are with students in downtown Chicago. Since 1893, North Park University has engaged the city as its dynamic place of learning and service. In David L. Parkyn's own words, "Chicago is our classroom and all Chicagoans are our teachers." (Courtesy Office of External Relations, North Park University.)

A block party was held for alumni, students, faculty, staff, and neighbors during the 2006 homecoming. This popular new tradition has become the largest campus event and a signature event within Chicago's Albany Park community. Each year Carmen and Spaulding Avenues are blocked off, and by 2008, nearly 5,000 people enjoyed live music, games, and a barbecue. Booths along the streets feature North Park University's departments, student groups, and neighborhood partners. (Courtesy Office of External Relations, North Park University.)

North Park University's most recent Fulbright scholar, Rebecca Miller, received the prestigious award to teach English in Indonesia and to study Bahasa Indonesian for 10 months. The 2007 graduate says she initially came to North Park University to live and learn in an urban center. (Courtesy Office of External Relations, North Park University; photograph by Eric Staswick.)

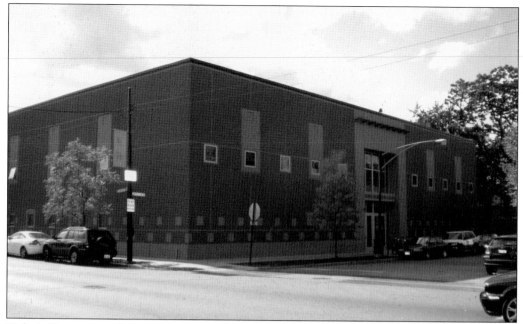

Helwig Recreation Center, named in honor of David and Nancy Helwig, opened in 2006. The $12.5 million, 68,000-square-foot fitness and athletic facility includes a climbing wall, a 5,000-square-foot weight room, a 5,000-square-foot fitness center, and a fully equipped athletic training area. (Courtesy Joanna Wilkinson.)

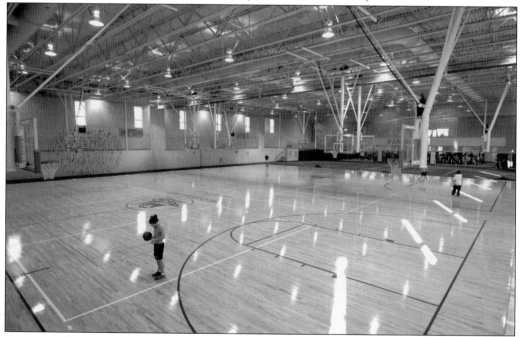

The main floor of Helwig Recreation Center has a two-lane, 200-meter running track, two full-size wood basketball courts, and a 35-meter artificial turf field. There are 4 classrooms and 13 offices located on the upper level. (Courtesy Office of External Relations, North Park University; photograph by Eric Staswick.)

Sawyer Court Residences was purchased in 2006 from a developer who was converting the apartment building into condominiums. North Park University purchased it before any units were sold, and the building was modified to provide housing for 100 students in 28 units. It is located at the southeast corner of Sawyer Avenue and Argyle Street. (Courtesy Joanna Wilkinson.)

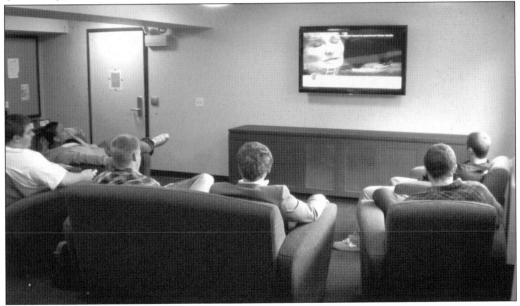

Burgh Hall was completely renovated between 2006 and 2008. The restrooms received new plumbing, fixtures, tiling, and private showers during the first two summers. The remainder of the building was renovated in the summer of 2008. The entire building was painted and rewired; the hallways received new ceilings, lights, and carpeting; and the dormitory rooms received new flooring, furniture, and doors with card-operated proximity locks in the $4.5 million renovation. (Courtesy Joanna Wilkinson.)

The North Branch flooded the Albany Park neighborhood on September 14, 2008, after Chicago received over seven inches of rain in a 24-hour period, and Anderson Hall (above), Burgh Hall, and Magnuson Campus Center had to be evacuated. The flood was reminiscent of floods that plagued the campus before the riverbed was resurfaced with a concrete slab in 1940 (see the photograph on page 22). (Courtesy Paul Johnson.)

The interior of the old gymnasium was restored to its original appearance during the summer of 2000. The vaulted wood-deck ceiling and metal trusses were uncovered, and the hardwood floor was restored (compare with the photographs on pages 29, 62, and 68). The building was renamed Hamming Hall in honor of Kenneth and Joyce Hamming in 2004. This photograph shows the multiuse room serving as a temporary dining hall after Magnuson Campus Center was flooded in 2008. (Courtesy Joanna Wilkinson.)

Psalm 111:10, the Swedish inscription near the entrance of Old Main (above), was originally suggested by 1893 board member Swen Anderson, who had originally seen it over the entrance of a school building in Sweden. As one of the guiding precepts of North Park University, the English translation "the fear of the Lord is the beginning of wisdom," was included in the selection of four texts to be inscribed in the stonework surrounding the compass in the center of the redesigned campus green space in 2003 (below). The other inscriptions are "I am a companion of all who fear you" (Psalm 119:63), "And what does the Lord require of you, but to do justice and to love kindness and to walk humbly with your God?" (Micah 6:8), and "Test everything: hold fast to what is good" (1 Thessalonians 5:21). (Above, courtesy Joanna Wilkinson; below, courtesy Office of External Relations, North Park University.)

ACROSS AMERICA, PEOPLE ARE DISCOVERING SOMETHING WONDERFUL. *THEIR HERITAGE.*

Arcadia Publishing is the leading local history publisher in the United States. With more than 3,000 titles in print and hundreds of new titles released every year, Arcadia has extensive specialized experience chronicling the history of communities and celebrating America's hidden stories, bringing to life the people, places, and events from the past. To discover the history of other communities across the nation, please visit:

www.arcadiapublishing.com

Customized search tools allow you to find regional history books about the town where you grew up, the cities where your friends and family live, the town where your parents met, or even that retirement spot you've been dreaming about.